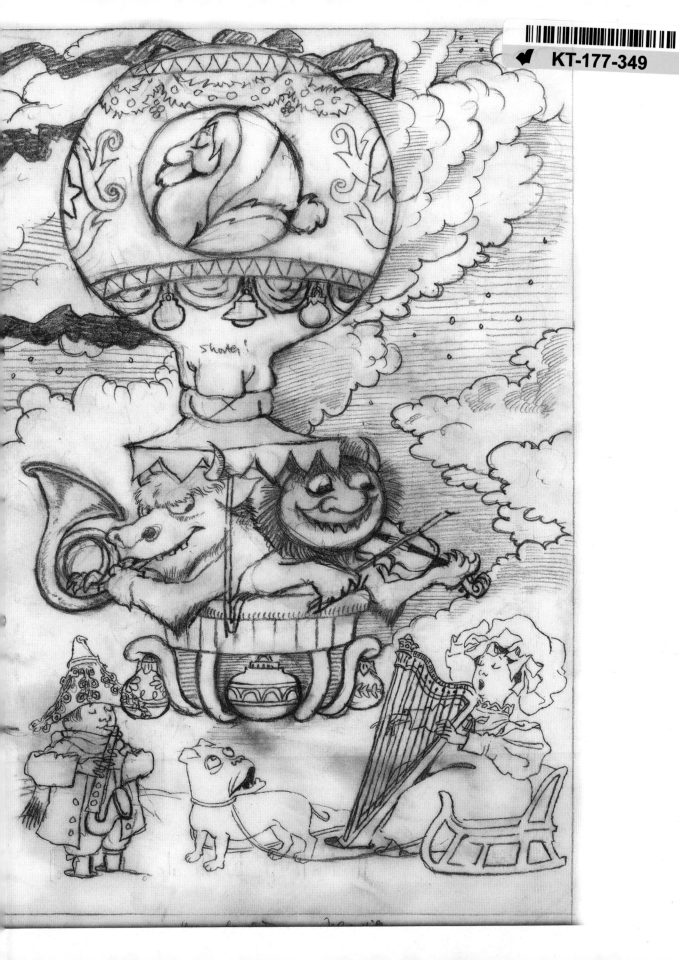

MAKING MISCHIEF

MAKING MISCHIEF

A MAURICE SENDAK APPRECIATION

GREGORY MAGUIRE

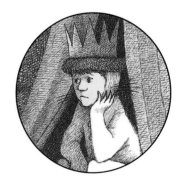

WM

WILLIAM MORROW
An Imprint of HarperCollins*Publishers*

FIRST EDITION

Designed by Joel Avirom, Jason Snyder, and Meghan Day Healey

Library of Congress Cataloging-in-Publication Data

Maguire, Gregory.
 Making mischief : a Maurice Sendak appreciation / Gregory Maguire.—1st ed.
 p. cm.
 ISBN 978-0-06-168916-1
 1. Sendak, Maurice—Criticism and interpretation. I. Sendak, Maurice. II. Title.
 III. Title: Maurice Sendak appreciation.
 NC975.5.S44M34 2009
 741.6'42092—dc22
 2009017357

 09 10 11 12 13 IN/WZ 10 9 8 7 6 5 4 3 2

A NOTE FROM MAURICE SENDAK

It should be enough to count Gregory Maguire as a friend, and I do. True, I might have become unsettled to learn he was poring over the pages of my books as he has done over those of some of the great children's storytellers and story merchants of the past—Grimm, and Andersen, and L. Frank Baum. But I admired Gregory's audacious examination of my work when I heard it presented in 2003, and I admire it more to see it in print. I trust in his generous spirit as well as his candor, and he has a usefully unblinkered eye.

The particular mischief made in these pages constitutes, in a way, a late but welcome collaboration.

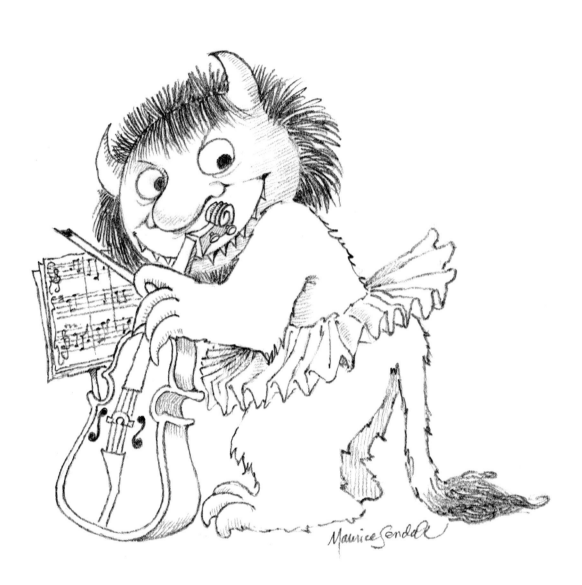

INTRODUCTION

On April 5, 2003, American artist Maurice Sendak delivered the annual May Hill Arbuthnot Honor Lecture sponsored by the Association for Library Service to Children, a division of the American Library Association.

The lecture was held at the Massachusetts Institute of Technology, jointly hosted by the Cambridge Public Library and Children's Literature New England, Inc.

April 5, 2003, was also the day American forces went into Baghdad. Sendak's lecture was titled "Descent into Limbo."

His remarks were preceded by a half-day symposium led off by "Making Mischief: A Sendak Appreciation," from which this book derives.

[I]

YOU ARE GIVING A KICKOFF TALK at a very terrific university in Cambridge, Massachusetts. It is intended to be a cheery, upbeat encomium, and begins in such a manner; but suddenly you remember that the keynote speech to follow is titled "Descent into Limbo." To make matters worse, a wild rumpus of a sleet storm blows through the room and delivers your notes onto Massachusetts Avenue, along with the slide projector, the slides, and the audience. What do you do, dear?

Sing "On the Sunny Side of the Street" in a very small voice.

I remember the day I met Maurice Sendak. I was a new graduate student just arrived in Boston in July of 1977. Barbara Harrison, founder and first director of the Center for the Study of Children's Literature at Simmons College, introduced us, and I joined a small group on a rooftop terrace to eat a picnic supper and watch the Independence Day fireworks. I didn't say much that evening, suffering a minor fright in the presence of one of my heroes. Nor could I manage a bite. At one point Maurice remarked, "You're not eating?" and I

mumbled, "It's sort of embarrassing to eat in front of the guest of honor." "I'm eating," he pointed out. "I'm the one who should be embarrassed."

Another student, making a blithe associative leap, remarked, "The Queen of England never eats in public. She doesn't like her subjects to see her engaged in anything so ordinary."

I suggested that maybe it wasn't protocol; maybe the Queen was reticent because she knew her table manners were atrocious and she snorted when she ate, like a pig. Maurice laughed, perhaps more heartily than the conceit deserved. An episodic but enduring friendship took root.

I remember the exchange because I was startled that he laughed; I'd been sure I would spill coleslaw on my lap or choke on a watermelon seed or accidentally compliment our guest speaker on a book someone else had illustrated.

Today, although I admire Sendak's work even more than I did in 1977—well, there was so much more to come—I can still taste the ferrous tang of terror at speaking to the original wild thing himself. Writing about his work affords a useful critical distance that affection tends to compromise.

I like when a piece sets out its agenda at once, with an abstract or a précis. Like the one-sentence discussion in *TV Guide* of what the soaps are featuring today: "Amber finds out she has a twin." With that postcard from the future, you know what you're getting into. With this book, let me suggest that you can either choose to read it through as a kind of appreciative salute, or you can relax

into your chair and turn the pages as slowly as you like, back and forth as new apprehensions strike you, letting the images speak to you as well as the words. Or you can go to the window and watch the rain turn to ice.

Making Mischief is subtitled *A Maurice Sendak Appreciation*. It's intended—in the minds of an audience that grew up on Sendak's oeuvre, and who hasn't at least in part?—to refresh the memory of his motifs and accomplishments, to suggest a few of his inspirations. Some of the images will be among the best loved of our childhoods. Others may be less well known.

Like everyone writing for children during the past fifty years, I've always hoped that Maurice Sendak would illustrate a book of mine. Here, in a sense, I get my wish at last, in a mischievous way: by writing a book around his art. How pleased I am that Maurice has agreed to this project, retroactively allowing his art to support my argument. I hope, in turn, that my words serve as illustration for his exceedingly articulate pictures.

As I prepare this book for publication, Sendak has turned eighty. Despite a menacing brace of health problems and personal sorrows, he is still working. It seems a fitting moment to look back over his sixty-some years in the field of book-making. But rather than examining his artistic development chronologically, I'm choosing to consider his body of work as if it were a united entity, a single creative act that has taken six decades to compose.

Regardless of the medium, certain artists find a way to do work that is instantly recognizable—besides Maurice Sendak, my own heroes, for different reasons, include Emily Dickinson, Bach, Faulkner, L. M. Boston, Walt Whitman,

Shakespeare, E. M. Forster, Bonnard, Laura Nyro, Keats, Isabella Stewart Gardner, the carvers of the Parthenon Marbles at the British Museum, Lewis Carroll, Proust (what I've slogged through so far . . .). Listing favorites like this is a mental game one can play for days on end, like Desert Island Discs or solitaire.

Of some artists it seems useful to ask if every iteration, major or minor, embellishes on a guiding notion so insistently that the body of work might be considered as a single gestational offering. Sure, there are highlights and greatest hits, moments so deeply embraced by the public that they risk becoming clichés. But one of the tools we can use to ascertain how well tempered a life work remains is to ask if a work can survive adoration, commercial exploitation, even parody, and still retain its power to stake its aesthetic claims over and over again. Some works resist being diminished even in the process of passing, chronologically, from novelty to classic. Major work doesn't bore through repetition but expands, whispering its secrets more deeply and richly every time it is encountered.

Another way to suggest my approach is to ask what characteristic, in the work of any distinctive artist, is irreducible? Without quoting a line of Dickinson, how might we describe an indisputably Dickinson poem? A Shakespeare characterization? A Forsteresque conundrum, a Sondheim attitude, an Alan Bennett caution, a Joni Mitchell plaint?

I won't attempt to name Sendak's theme. I will look at the body of his work casually, colloquially, admiringly, from several different approaches in order to show you what I see, and why I think the word *genius* isn't grade inflation.

Since he was in his midthirties, Sendak has drawn the attention of major reviewers and cultural pundits: Salman Rushdie, John Updike, John Gardner, and Bruno Bettelheim among them. There have been more than a few raised eyebrows and possibly some raised voices.

The collection of essays by Maurice Sendak, *Caldecott and Company*, can be bracketed on the shelf by those two lusciously presented chronological studies, Selma Lanes's *The Art of Maurice Sendak* and Tony Kushner's *The Art of Maurice Sendak: 1980 to Present*. John Cech's *Angels and Wild Things* adds a useful critical angle advanced through its subtitle: *The Archetypal Poetics of Maurice Sendak*. These books are essential references for people who want to know what Sendak said, and what was said about him, and when; what he created, and in what order.

I'm more interested in noting the visual conversations Sendak has had with himself and with the artists he has admired. Admired, borrowed from, stolen from, paid homage to. The company he keeps is extensive and eclectic.

The artist as scavenger is an ancient notion, but no other children's book artist has had the nerve to borrow with the abandon and playfulness of Sendak. One could be dubious about the need, when Sendak has such a font of his own native imagery on which to draw, but the success of his use of reference material sweeps away anything that smacks of dissent. I can hear him sending up his critics, mimicking their mandarin reservations: "Dürer? Blake? A kiddie-book artist has no business leafing through the portfolios of the big boys."

Sendak's license to borrow is founded on this principle: He has a vision that is larger than he is, and larger than his critics'. He lives in thrall to the temptation of that siren vision—or to the call of that muse, if you prefer the standard metaphor—and he pays as he goes, by giving us work of unusual vigor, sobriety, and novelty. There is nothing slavish about his homages.

Mostly I'll forgo sharing images of source material that has been documented in other books, like Albrecht Dürer and the frontispieces by Ludwig Grimm of the original editions of the *Household Tales*, for *The Juniper Tree*; or like Thomas Rowlandson, an eighteenth-century caricaturist about whom I know precious little anyway. A volume larger than this monograph could be composed entirely of Sendak's visual quotations. I intend merely to suggest part of the process by which he works. To start, I'll flash at you a few sympathetic correspondences that my own eye has picked up over the years.

Down a few steps from the kitchen, Sendak's studio occupies a peninsular outpost of his rambling house. Outside the artist's window conservation land lends a pastoral tone.

The room is small—one might say cozy, one would certainly say crowded. It is stuffed with stuff. In bookcases and cupboards the artist has jammed personal icons, treasures, books, sketches, amulets whose significance he won't share, talismans, memento mori, keepsakes.

If you're invited, you hunch over the drawing table to peer at the latest work in progress. Your eye is riveted to the drawings.

As you lean over the drawing table, as you focus on the work, you lose the sense of coziness; at your shoulders, your hunched back, it seems as if the walls rise and the ceiling opens into a high rotunda capped with a dome, and columned niches on all sides bulge with alabaster busts of the household gods.

A family of companions gazes down fondly—one presumes fondly—to look over your shoulder at the work in progress.

Mozart is there, of course; indeed he's everywhere in Sendak's work, sometimes hidden in a maze of obscure references, sometimes glancingly sighted.

But who else? Who else besides Dürer and the contemporary photographer John Dugdale and Boutet de Monvel and Ludwig Grimm? Whose profiles crowd this imaginary pantheon? Who else besides William Nicholson and Beatrix Potter and Wilhelm Busch and George MacDonald? The clouds in the room part (this room has actual weather in it—you can't be surprised). In the rich dense atmosphere, one can almost identify the chosen relatives up there:

Sendak's beloved editor at Harper & Row, Ursula Nordstrom, is the presiding poltergeist, indomitably ready to say something saucy, in a garden full of *Dear Mili* blossoms.

Herman Melville is there, clutching a pen that almost turns into a sunflower, dreamy from his time in the sultry tropics—sultry, or maybe even hot.

Heinrich von Kleist, the first great German dramatist of the nineteenth century, is present, clutching his own bosom, appearing curious and slightly surprised at his companions in this pantheon; Peter and Iona Opie, the folklorists and historians of childhood games and doggerel, and Sebastian Walker, founder of Walker Books and Candlewick Press, perch with their talons on a convenient lintel. Sendak perches there too: a compliment to himself, a challenge, an honest assessment, a hope?

You can spot even the broad-
spirited specter of a fresh-faced
president who, in 1993, briefly
gave us reason to hope that
to be grown-up might not
always mean to have to take up
permanent residence in limbo.

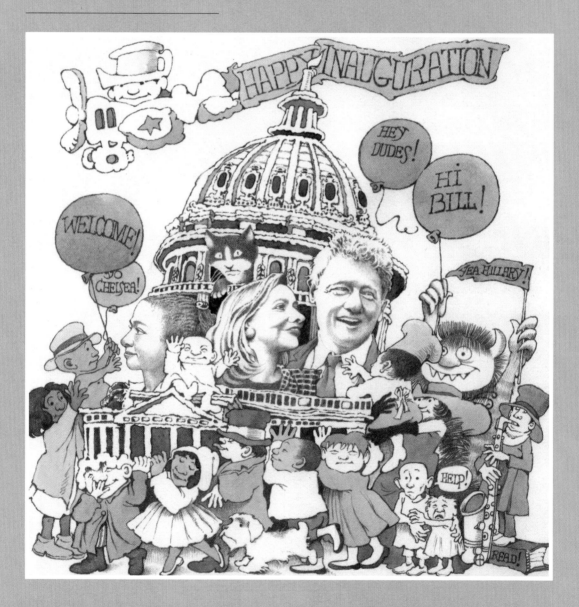

Randolph Caldecott, whose influence on Sendak is well documented, looks down beamingly. Here he's pictured with a wild thing and a couple of creatures who wandered out of the Mother Goose rhyme "Hey Diddle Diddle."

Sendak called his own collection of essays *Caldecott and Company*, anticipating the litany of heroes and comrades I am echoing. Sendak's heroes, like mine, possess their unimpeachable distinctions, live and create as themselves down to their fingernails and claws.

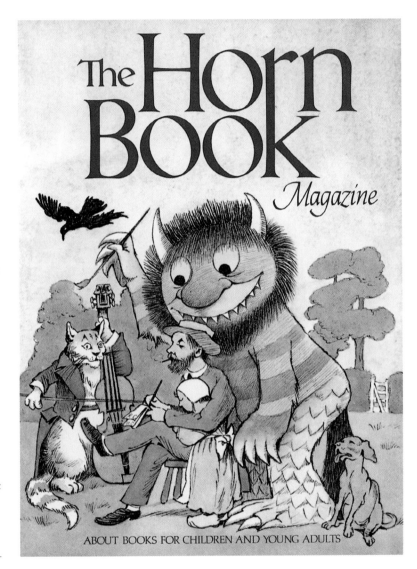

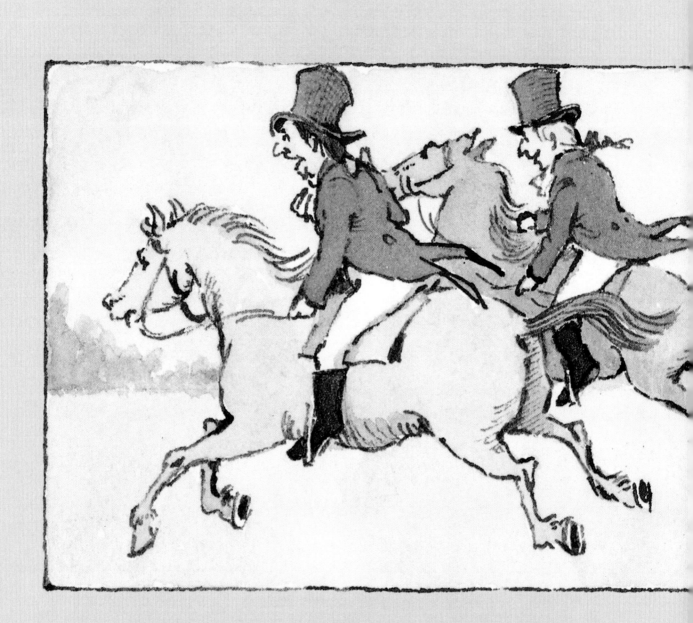

From the clouds come distant strains, *ta-ra, ta-ra*. Bolting by are some famous hunters drawn by Caldecott, which Sendak admires for their verve, their dramatic urgency—hence a Sendak homage.

Those are all the famous noggins and noses I can make out at a quick glance; the clouds close in. I can guess who else might be up there, farther up, cloaked in clouds of glory but hardly anonymous.

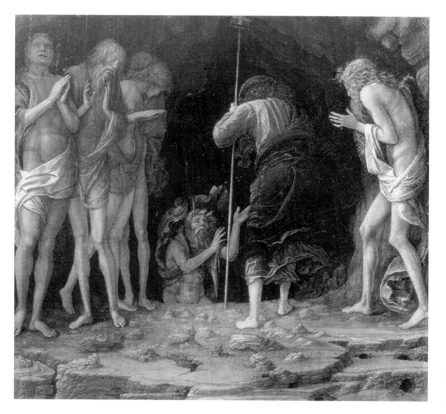

Andrea Mantegna, for one. His painting called *Descent into Limbo* gave Sendak not only the title of his Arbuthnot Lecture but also the inspiration for the design of the cover of *We Are All in the Dumps with Jack and Guy*. On what fresh lip of hell do we now stand, and when shall we emerge?

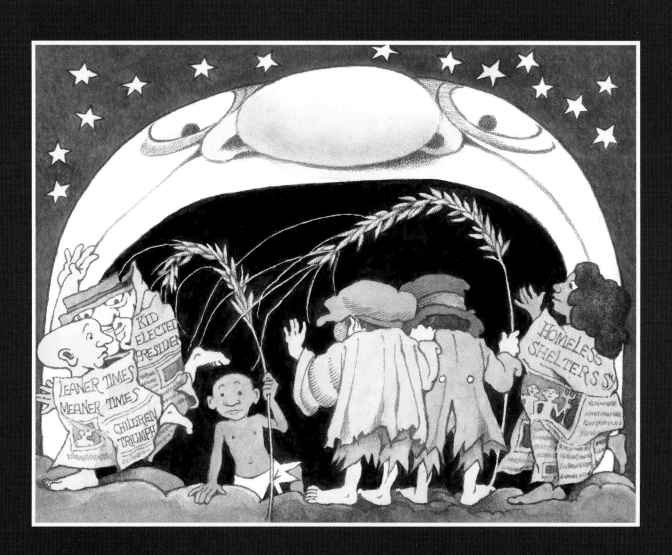

No less a presence than William Blake is enshrined in Sendak's pantheon, and Blake's scalloped recess is finished in hammered gold leaf. Blake of the "fiery line," as Nicholas Pevsner said, is nearly preeminent among Sendak's inspirations. Blake is evoked in ways obvious, subtle, and subversive.

We compare the gloriously colored child of the universe in Blake's *Glad Day,* or *The Dance of Albion,* with the image Sendak has presented, suggesting the eponymous Pierre in the Herman Melville novel as an erotic, ecstatic Superman.

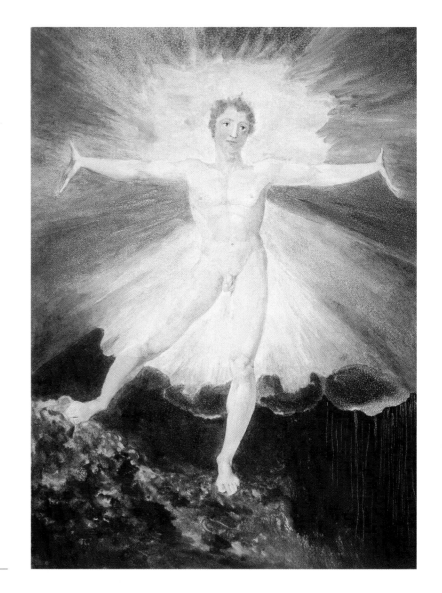

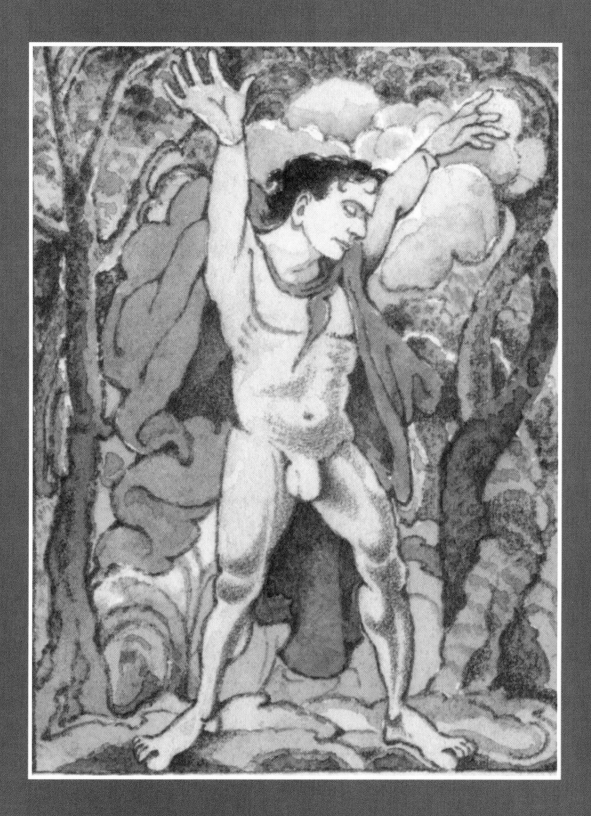

When Pierre asserts, "I shall declare myself an equal power with both [God and man]; free to make war on Night and Day . . ." we recognize him by his form and position to be the spiritual descendant of the brave Milton as depicted by Blake on the cover of *Milton: A Poem.*

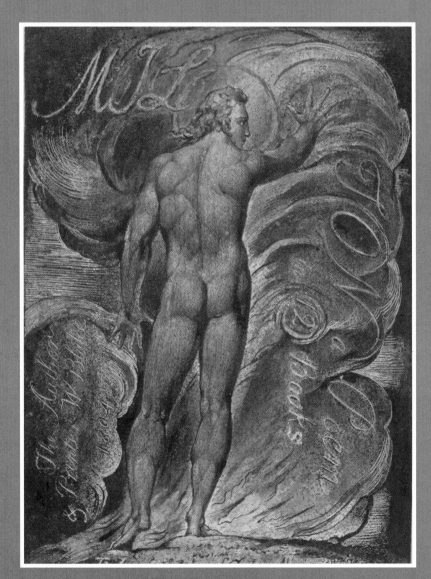

The desperate in Blake appeals to Sendak as well as the epiphanic. Note Oothoon and Bromion tied back-to-back in a cave from Blake's *Visions of the Daughters of Albion.*

Sendak borrows both the mood and coiled nautilus line to evoke the passage from Melville's *Pierre:* "For in the grave is no help, no prayer thither may go, no forgiveness thence come; so that the penitent whose sad victim lies in the ground, for that useless penitent his doom is eternal, and though it be Christmas-day with all Christendom, with him it is Hell-day and an eaten liver forever." More imprisonment, and a hero is needed, of any stripe or gender or category.

The later Sendak gleans much from Blake, not only the febrile patheticism of the lurid skyscapes depicted, for example, on the cover of *Songs of Innocence and of Experience: Shewing the Two Contrary States of the Human Soul . . .*

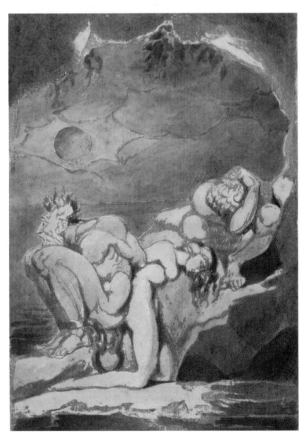

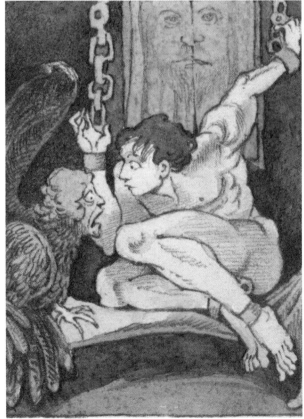

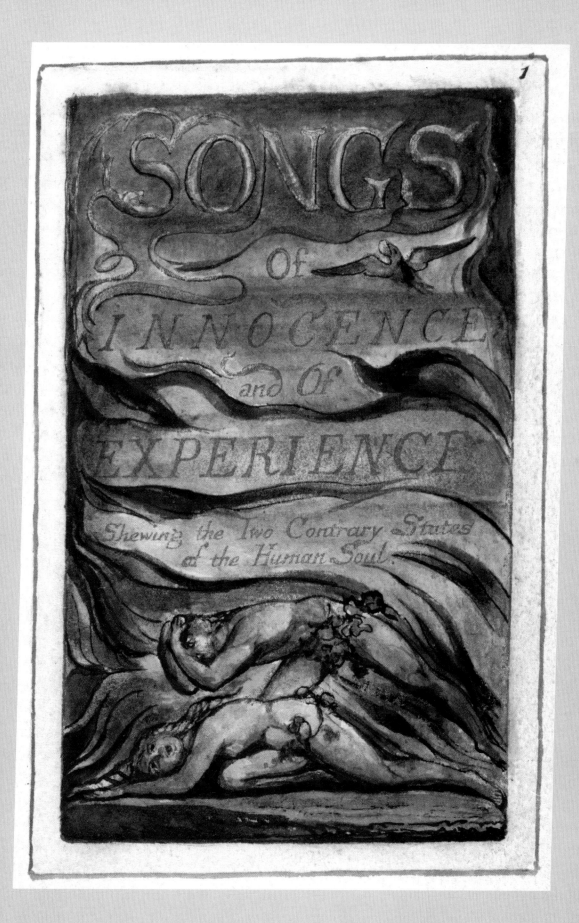

but also the very iconography
of sunflowers and nightmares
and flame-fringed storms of
the psyche, shown here from
an illustration that comes
early on in the rediscovered
Brothers Grimm tale
published as *Dear Mili*.

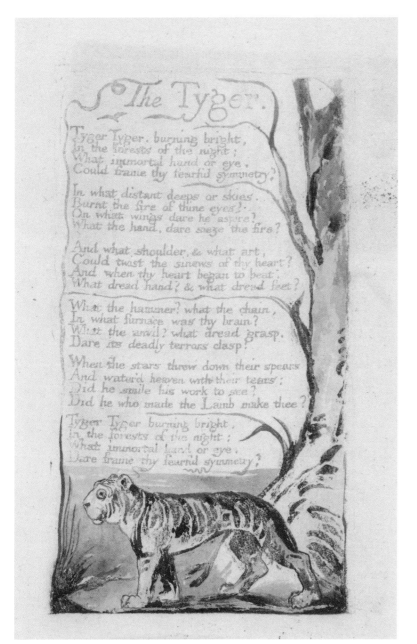

Finally, we note the influence of Blake as a designer. We observe the graphic sinews of the page from *Songs of Innocence and of Experience* called "The Tyger." Remember the beginning trochees of Blake's most famous poem—

> *Tyger, Tyger, burning bright,*
> *In the forests of the night;*
> *What immortal hand or eye,*
> *Could frame thy fearful*
> *symmetry?*

—and hear in this other text from Blake softer echoes: "Sleep, sleep, beauty bright, / Dreaming in the joys of night." In this page from Sendak's *Lullabies and Night Songs* the layout of tree branches breaks up lines of text. Note the peaceable kingdom, too; Blake's tiger resting to the music of a lullaby.

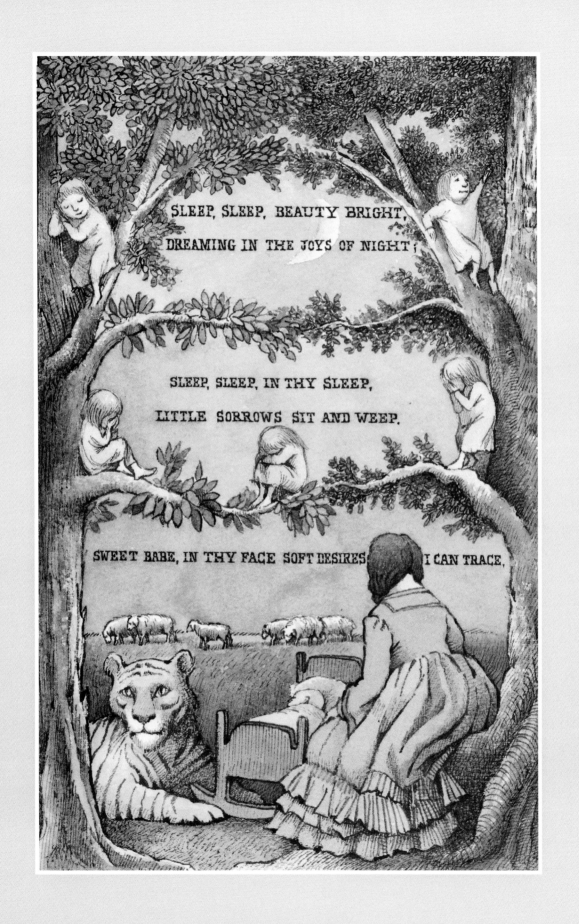

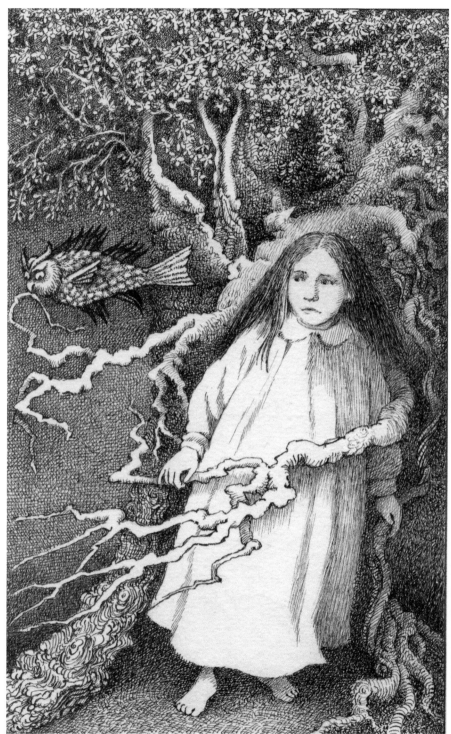

Lewis Carroll (Charles Lutwidge Dodgson) hovers up there among the muses in numerous ways. Here I concentrate only on Carroll as a photographer of Irene MacDonald, one of George MacDonald's children, in a photo called "It Won't Come Smooth."

In George MacDonald's fable *The Golden Key*, the female protagonist is appropriately named Tangle, a nice counterpart to "It Won't Come Smooth."

(Sendak has raised an
eyebrow of his own over the
Victorian cleric's practice of
photographing young girls . . .)

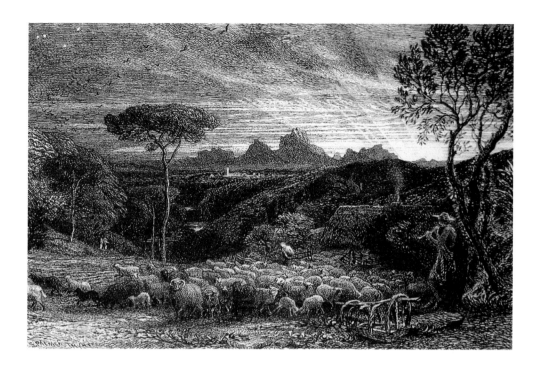

English Romantic Samuel Palmer has limned in a world of dense nocturnal mystery. *Opening the Fold, Early Morning,* was seen in the 2002–2003 exhibit, Maurice Sendak: Inside and Out, mounted at the Eric Carle Museum of Picture Book Art.

Interest in Sendak's influences drew me to the 2006 exhibit, Samuel Palmer (1805–1881): Vision and Landscape, mounted at the Metropolitan Museum of Art. It remains one of the most arresting exhibits I've ever seen. Besides the brown ink-and-wash studies of rural buildings, the brooding etchings of skies built up by ten thousand knife strokes, the nearly phosphorescent cloudscapes, the dreamy sheep and pastoral languor, Palmer seems to have imparted to Sendak the poignancy of his apparent personal story: an artist whose probable history of romantic affections for fellow artists was suppressed and discredited by his peers and survivors.

Given the sympathy that Sendak must have felt—well, I do, anyway, just imagining this conjecture to be true—I understand better Palmer's enduring influence on Sendak. Many of Sendak's landscapes seem to breathe a paean to the calm, the midnight danger, the possibilities of a world of nighttime shadows and moonlit revelations . . . Limbo is only one aspect of the world; paradise also breaks upon us, fleetingly brilliant.

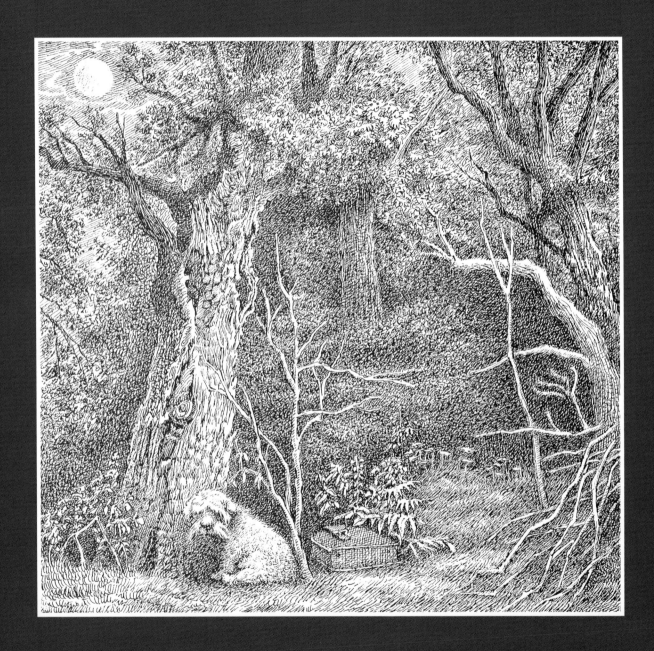

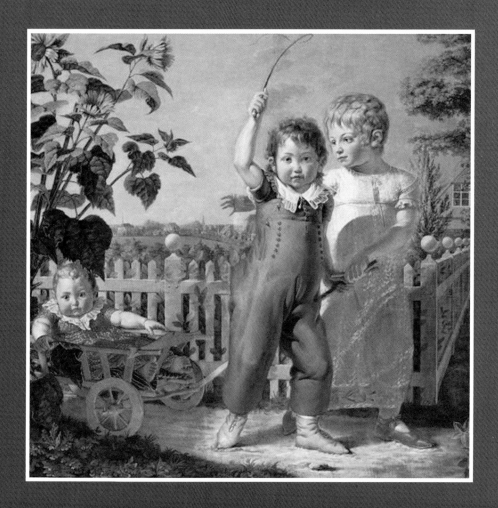

This palace of muses reaches quite a way up; you can see it from as far away as the Danbury Mall. Sendak's hall of idols has to be a terrific and a capacious pleasure dome; so many to be honored in its recesses, niches, and altars. The German Romantic painter Philipp Otto Runge has a spot. Here's his *Portrait of the Huelsenbeck Children.* Note the fence, the ominous sunflowers, the children without apparent parental supervision, and also note the strange glazed-eye look of these robust children . . .

———————————

In *Outside Over There* the
kids are more competent;
it's the father who is absent,
literally, and the mother, as
good as. Fence, sunflowers,
children on their own . . .
Sendak sees the ominous
in Runge's portrait and he
shuffles the elements so we
can see them in our own way,
in service to a different story.

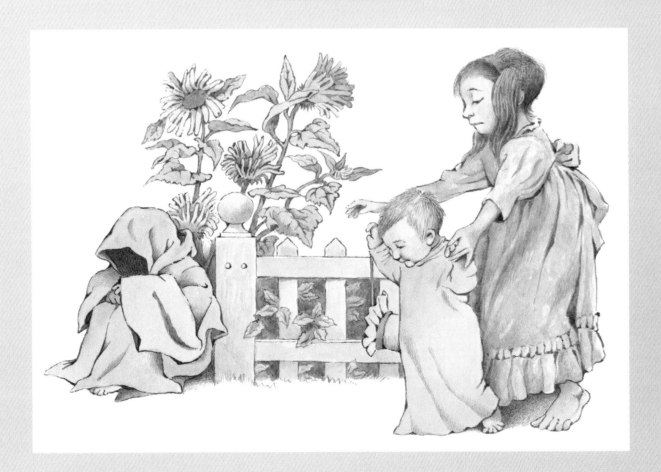

Hans Tegner, an early
illustrator of Hans Christian
Andersen's fairy tales, is in
Sendak's gallery of heroes.
Tegner supplied this
lithographic chapter head for
"The Little Mermaid," inspiring
another midnight swim, in
George MacDonald's *The Light
Princess*. (Why is the guard
looking away? I wouldn't.)

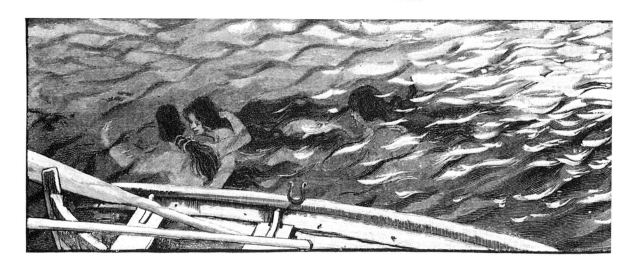

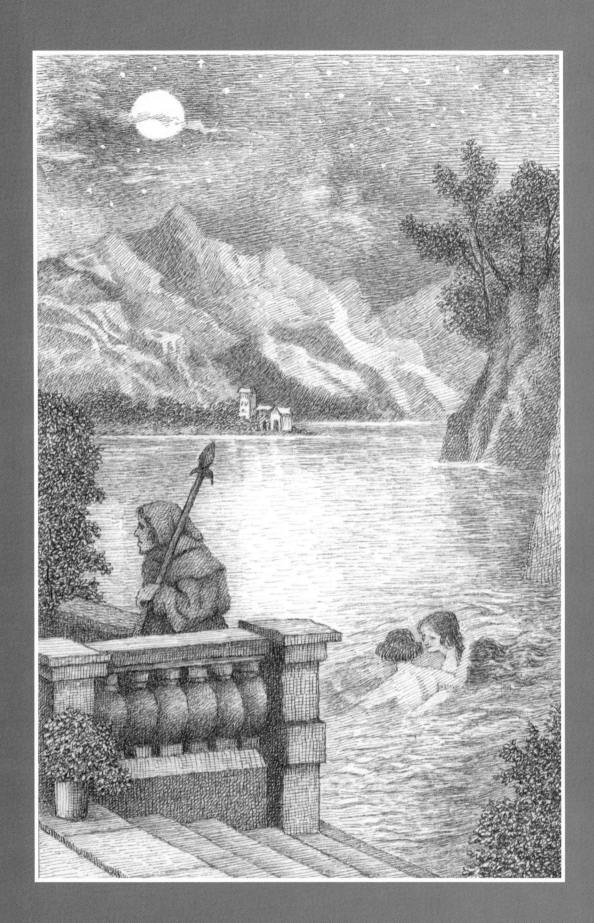

Arthur Hughes and others of his period—the second part of the nineteenth century—with their densely composed, emotionally compacted black-and-white illustrations, influenced the grave set pieces in *The Juniper Tree*.

Sendak's illustration for the story called "The Two Journeymen" is a masterwork of compression, not derivative of Hughes as to subject or execution, but an example of a Hughes-like charged drama, up close and personal, made more intense and even claustrophobic by the restrictive lines of the borders.

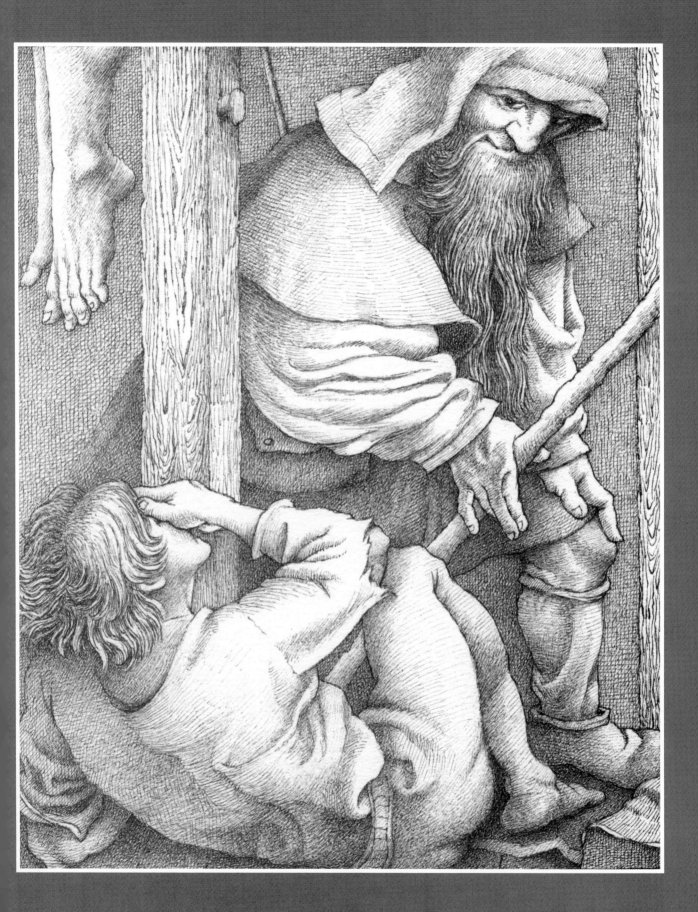

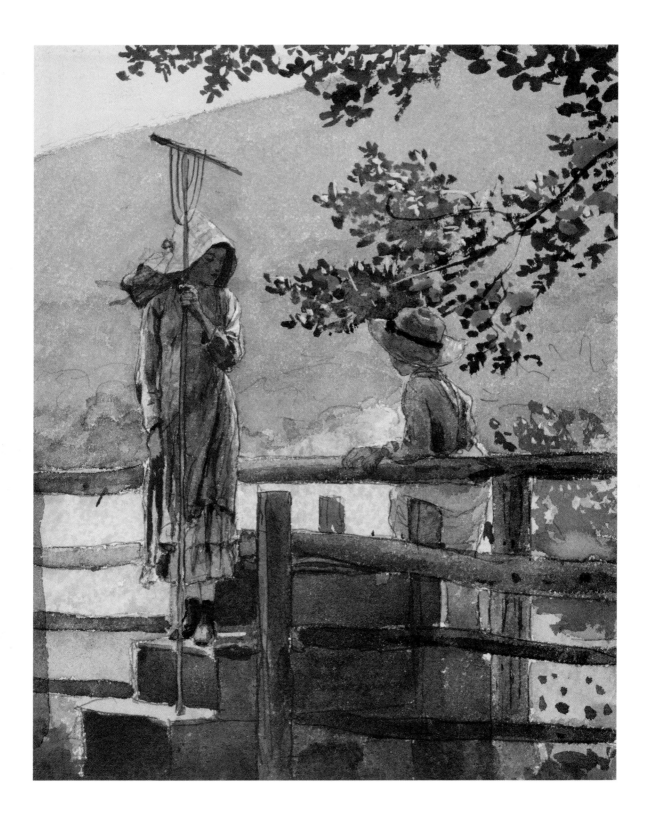

A shout-out to Winslow Homer high above us. Hi, Winnie! His 1876 Academy exhibition was criticized for being "bald as patchwork," aspects of the fluid lightness of his brushwork reminding one critic of a stage flat. Note the slope of the hill, the spray of leaves, the angle of the fence . . .

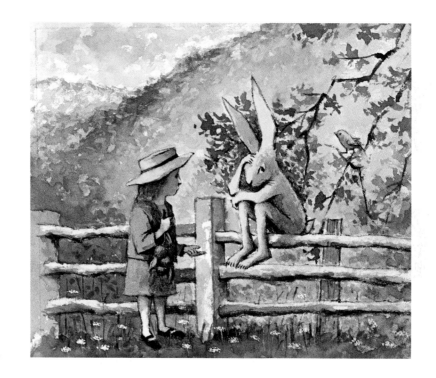

In *Mr. Rabbit and the Lovely Present* Sendak relies on Homer's technique of stippled watercolor and palette, as well as his visual concept, to communicate a rural moment of equipoise.

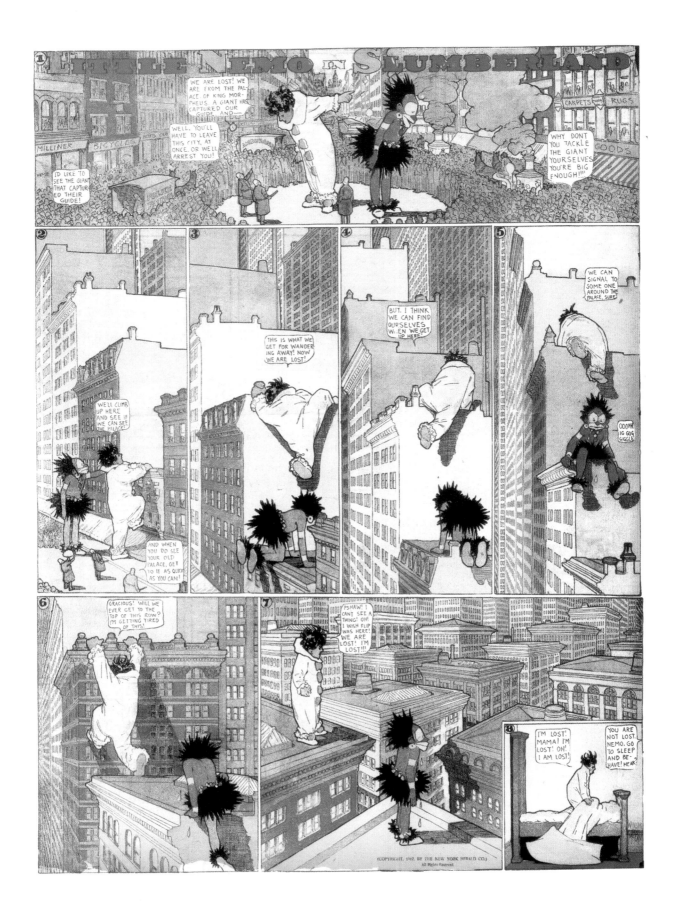

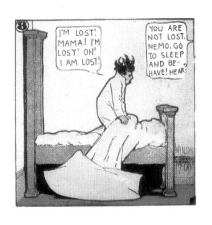

We note how Sendak borrows the notion of the fantasy journey, the last panel showing Little Nemo settling down into the confines of his bedroom, having awakened from his dream adventures. Little Nemo seems to have grown up to become the dad, sleeping tight, of Mickey in the penultimate page of *In the Night Kitchen*. Same bed, just about, same placement of the bed in the rectangle of the borders. (In affectionate families as well as hard-up ones, furniture is passed down through the generations . . .)

Winsor McCay—another Winnie, halloo up there—the early-twentieth-century newspaper comic strip artist who drew *Little Nemo in Slumberland*, saw in a newspaper's funny pages the narrative possibilities of a comic strip's conventional grid design. He chose to make the variability of the panels a tool in his own graphic arsenal, thereby reinforcing the sensation of the imprisonment by, and release from, a bad dream.

This image of Reginald
Birch's, *Vixen and Tip*, comes
from *The Wild Animal Play*,
a theatrical piece by Ernest
Seton-Thompson published
in 1900. Are these ancestors
of Max, or do they prefigure
Ida and her baby sister from
Outside Over There? They
seem a bit too tame to make
very much mischief, at least
while we are looking at them.

Sendak's influence over
other artists has its parallel
in his influence over himself.
His revisiting of images sets
off a chiming of visual echoes,
if you will: familiar, old,
borrowed, new.

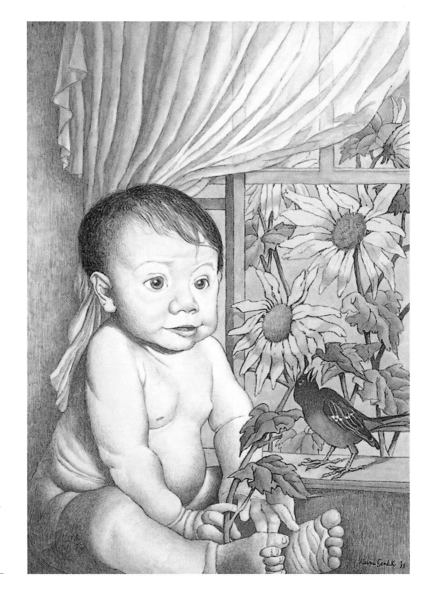

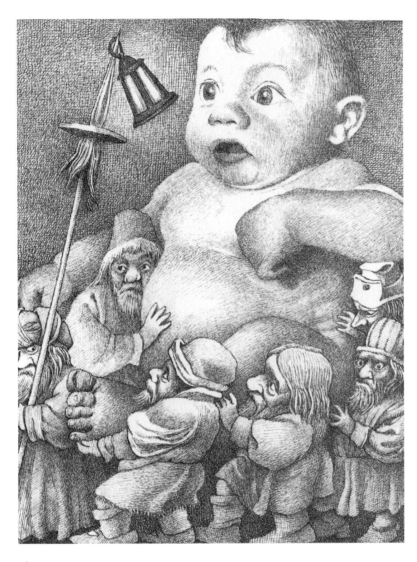

on his work. Once when
Maurice came to lunch, he
leaned upon a walking stick
previously owned by Beatrix
Potter herself. (I imagine she
used it to thwack little rabbits
out of the way as she stalked
her farm in the Lake District.)

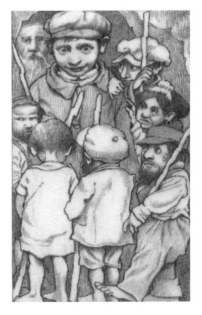

All artists borrow and
transform their material.
Above and right we see two
instances of enchantment: an
infant by the dwarfish light,
and a boy by his dwarfish
relatives, their heavy history,
their brilliant heavy attention

and pesky interference. Look
on, listen more, to see further
iterations of this motif. The
artist mesmerized.

Repeatedly Sendak has
credited Beatrix Potter,
Wilhelm Busch, and William
Nicholson for their influence

Knowing Nicholson's work as a painter and a graphic artist, I was thrilled to discover at last a copy of his picture book *The Pirate Twins*. In case you've never come across this lolloping masterpiece, here are the pages with which it opens.

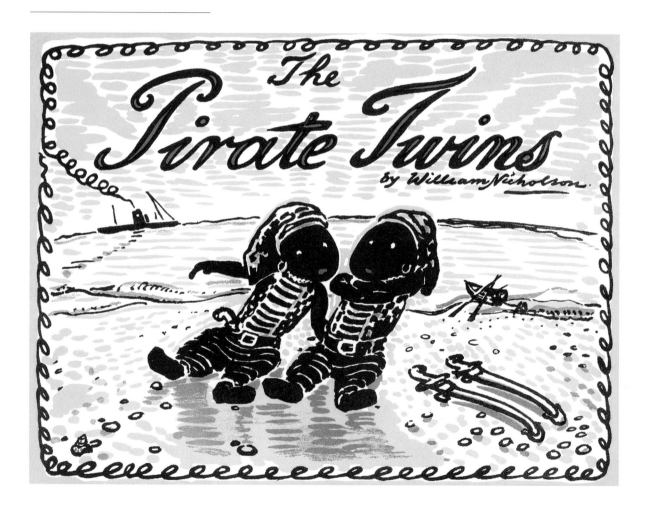

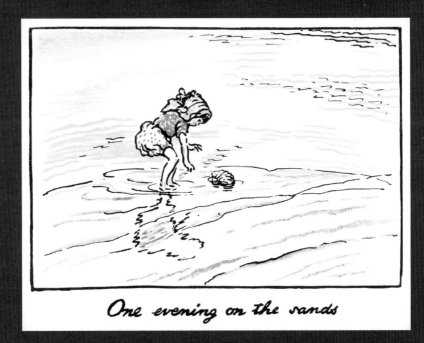

One evening on the sands

The story's first sentence is sustained through nine consecutive pages: "One evening on the sands / Mary found / the Pirate Twins— so / she took them Home / and bathed them / and fed them / on this / that /and the other."

In pacing—and in the notion of food as a reward after a rough passage—the susurrous text inspires: "The night Max wore his wolf suit and made mischief of one kind / and another / his mother called him 'WILD THING!' and Max said 'I'LL EAT YOU UP!' so he was sent to bed without eating anything."

2

Mary found

3

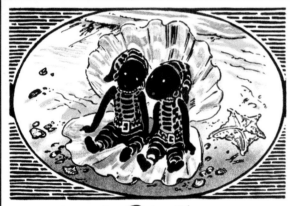

the Pirate Twins - - so - - -

4

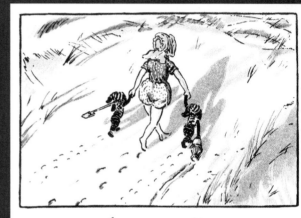

she took them Home

5

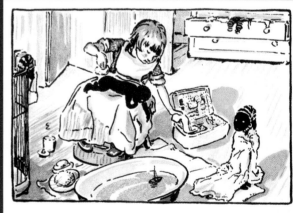

and bathed them

6

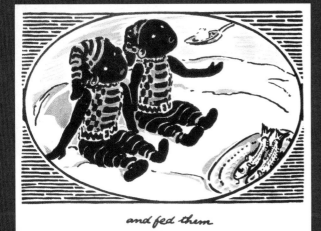

and fed them

7

on this

8

that

9

and the other

Likewise, Wilhelm Busch's
Max und Moritz seems a
persistent inspiration. Such
familiar names, Max and
Moritz!—they are ancestors
of the Katzenjammer Kids, and
also rapscallion relatives of wild
thing Max and, as we see in this
sequence, of Mickey in *In the
Night Kitchen.*

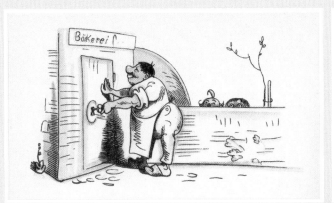 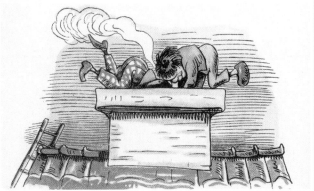

A baker opens his place of business as
the ne'er-do-wells peer over the fence
and then tumble down the chimney . . .

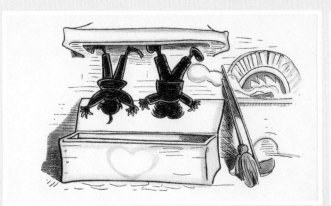 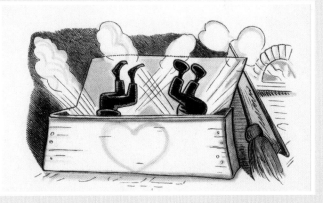

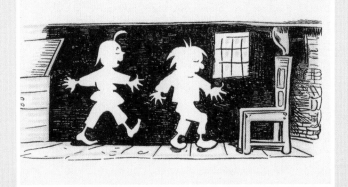

becoming blackened with soot,
and then whitened with flour . . .

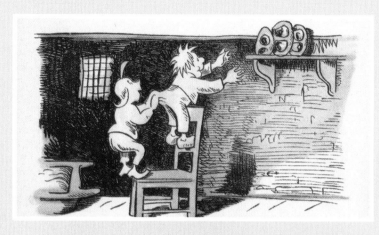

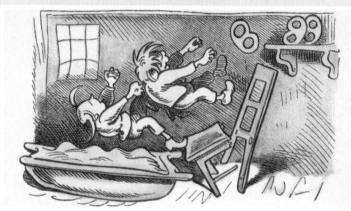

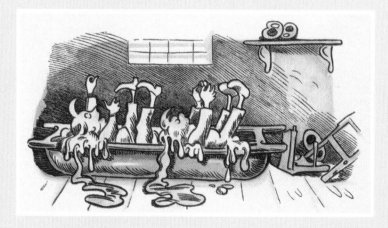

and, still up to no good, they reach for pretzels,
but break the chair and tumble into the pastry dough . . .

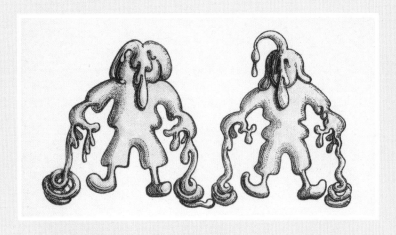

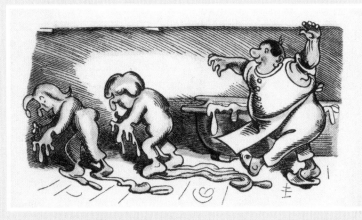

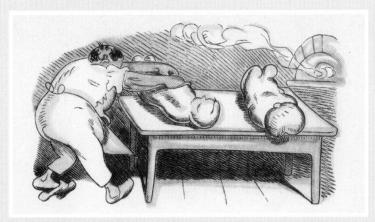

so when in their humiliation and incapacity they're discovered
by the master baker, they are easily rolled into loaves . . .

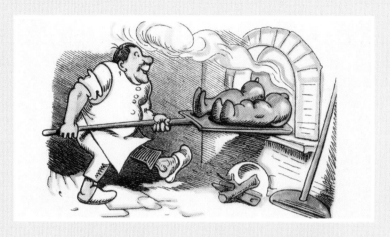

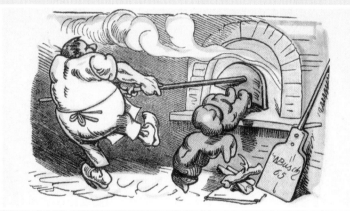

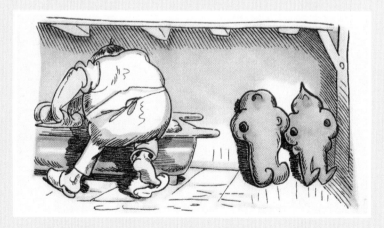

shoved in a wall oven . . .

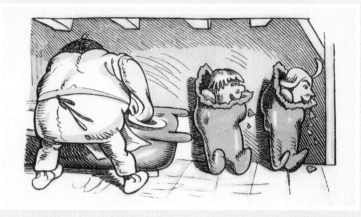

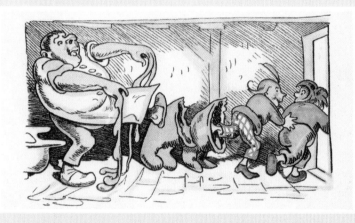

from which, like all comic heroes, they escape
unscathed. Good German children being practiced
in the art of devouring the gingerbread domiciles
of witches, they eat their way to safety, thus besting
the master baker at last. Escape from their chains by
means of mastication. Limbo is seldom so sweet.

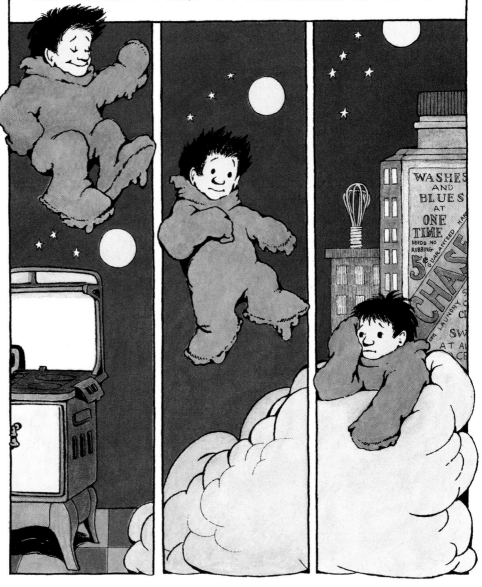

SO HE SKIPPED FROM THE OVEN & INTO BREAD DOUGH ALL READY TO RISE IN THE NIGHT KITCHEN.

The lunacy and rubbery good luck of the boys is part of the Sendak credo. *Max und Moritz,* with insane comic brio, loans to Mickey not only key elements of plot . . .

but also the aerodynamic fluidity of the protagonist bouncing across the page.

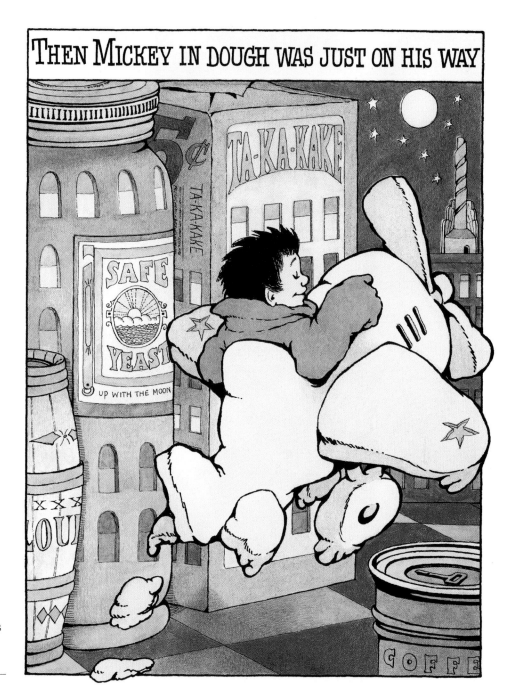

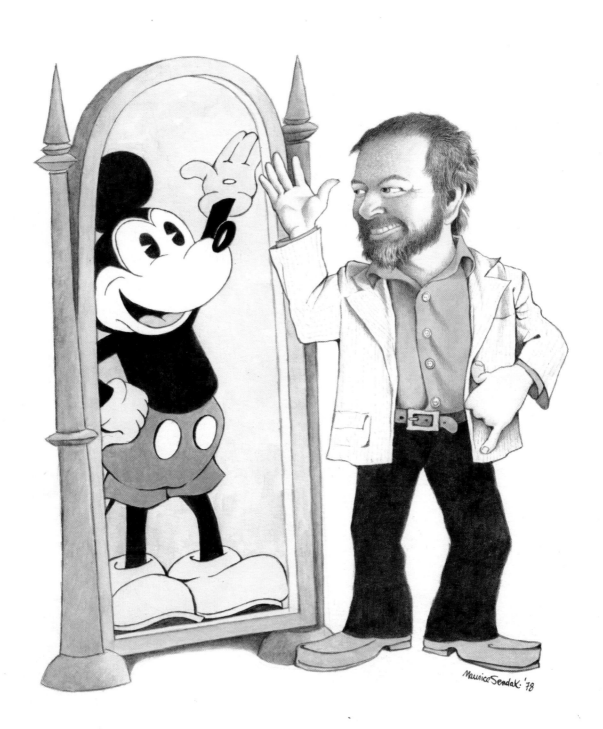

Maurice Sendak '78

On one hand, Sendak acknowledges his debt to the glamour of Walt Disney's Mickey Mouse, especially as seen in animated shorts on giant screens in 1930s Manhattan movie palaces. On the other hand, Mr. Rabbit has always seemed to me to bear a striking resemblance to a certain Warner Brothers headliner. Sendak's Mr. Wabbit, though cwafty, is less hyper than Bugs Bunny, as if tempered by Darvon or the recreational substance of that day, Nembutal.

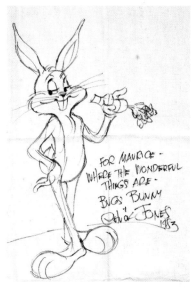

Born in 1928, Sendak is a child of his time. His picture books sometimes kowtow to the gods of the silver screen. (I like imagining that the famous Oliver Hardy, performing as the bakers of *In the Night Kitchen*, had to audition to beat out Buster Keaton.)

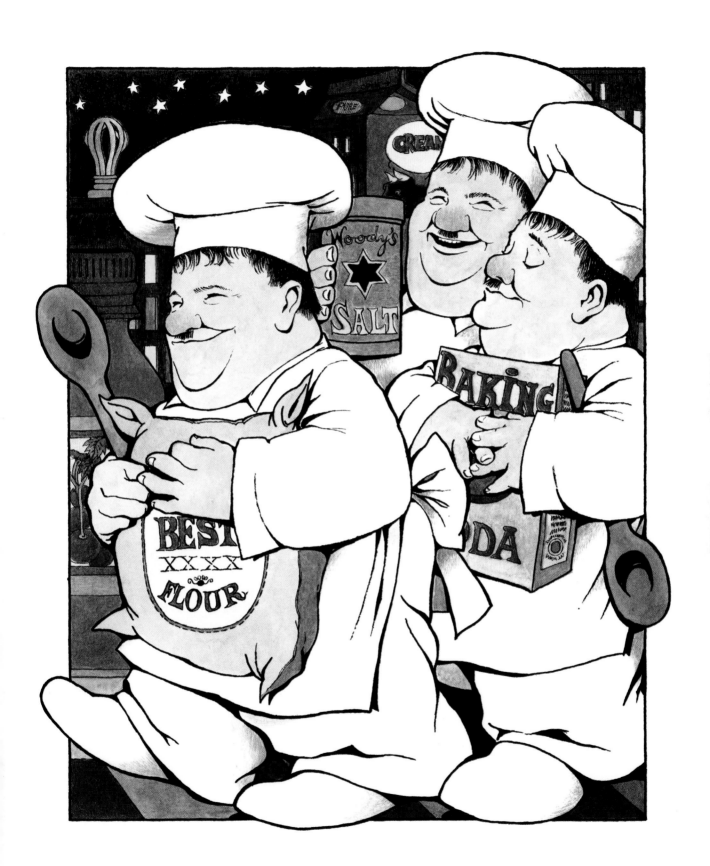

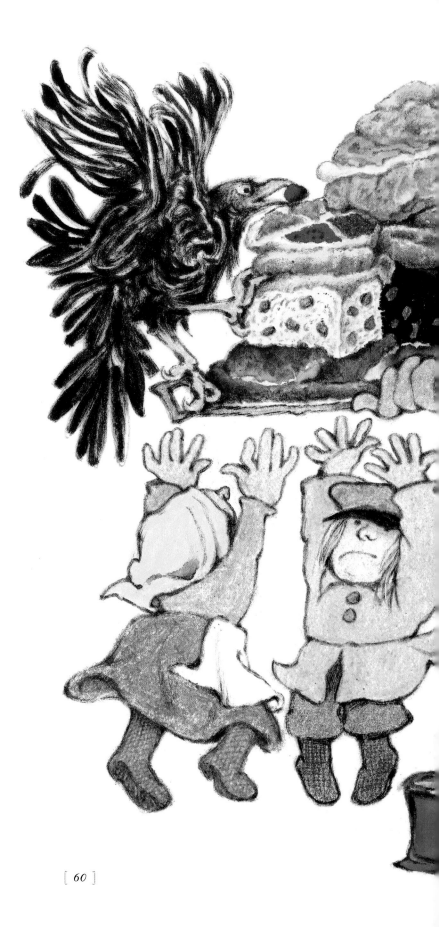

Sendak came of age when the flickering silent films strengthened, brightened, and became chatty—just as the shtetls of Eastern Europe, where his relatives still lived, were going quiet and dark. In that later masterpiece, *Brundibar*, a fable with an Eastern European setting that one might accept as happening simultaneously with the dreamy American raptures of *In the Night Kitchen*, Oliver Hardy makes a cameo. Dreams do that: allow our private heroes to show up again and again, just when we need them most. Nightmares allow the same of our enemies, alas, so it's good practice to identify our heroes if we can. The act of identification alone promotes the chance of their healthy influence upon us.

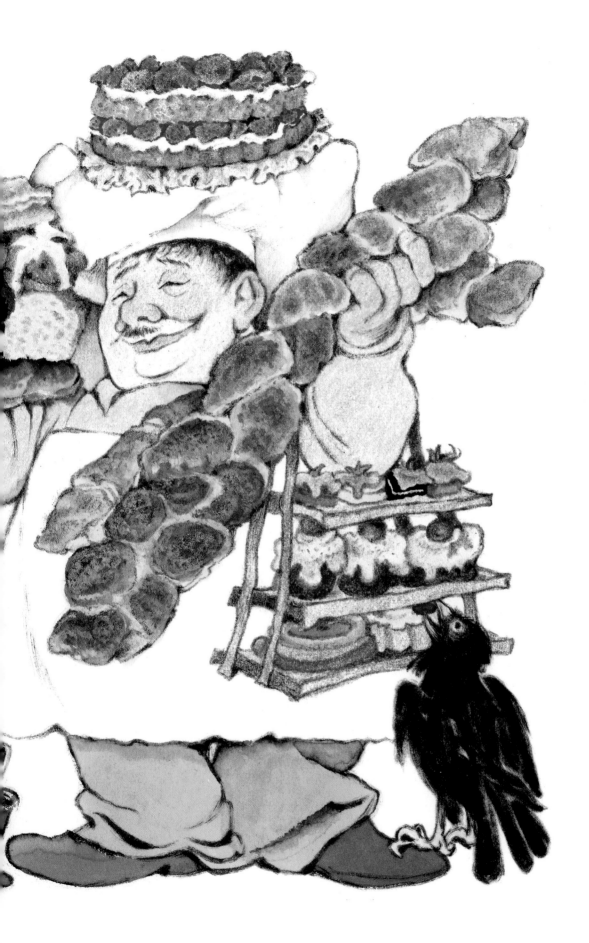

My rushed tour through Sendak's hall of muses (or is it a stable of heroes, or a village of insubstantial presences, or a legislature of silent partners?) offers only a first glimpse of influences. There's always more to discover, a diffused and arcane light shining from behind the highest clouds.

Every time I pick up some obscure collection of minor works of greater artists, I find Sendak's fingerprints on the pages already. I recognize new referents, doppelganger DNA, starting points for Sendak's allusions and atmospherics and sometimes compositional schemes. I have ceased being surprised. Sendak's appetite is voracious. He devours his heroes and brings them forth again in new form, new life, like a Brooklyn-born version of the Hindu Trimurti godhead composed of Brahma, Vishnu, and Shiva: the creator, the preserver, the destroyer all at once, albeit with the hectoring, scowling affection of a Jewish mother—one who wields a cudgel-like rolling pin against her enemies as adroitly as she might lean over a table with a sable-haired paintbrush, to draw her loved ones again, and again, and again.

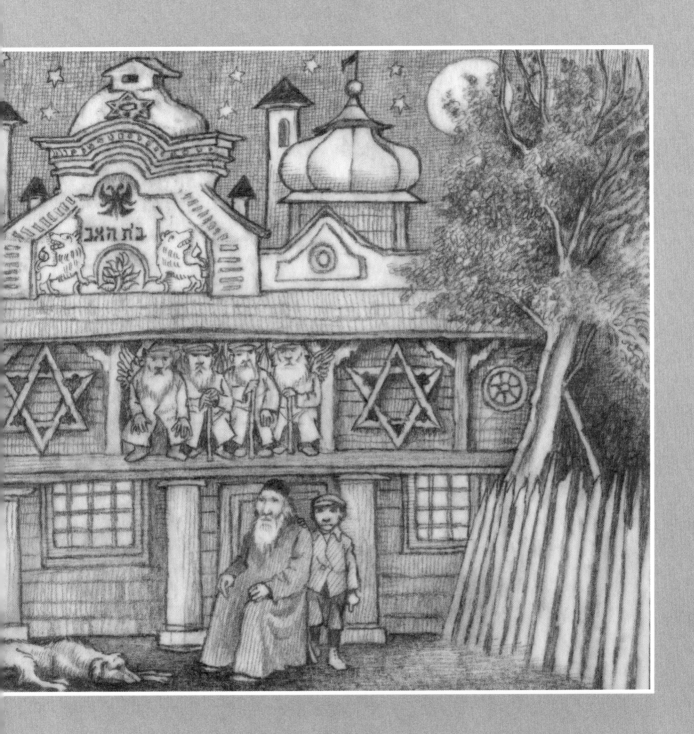

[2]

CHILDREN'S LIVES ARE FIENDISHLY HARD. Adults, having survived childhood, turn their minds to the future and, if they have a choice, generally retain only the rosier of childhood memories. Doubtless this is as it should be, productive for them and for society.

But children's books aren't for adults, they're for children. Children's material descends from a healthy profusion of contradictory origins: nursery doggerel, fireside fables, Bible lessons, tatters of myth, lopsided hunks of legend, cautionary tales, improving lectures, and ferociously apocalyptic object lessons. When commercial publishing of juvenile material began in eighteenth-century London, the strengths of children's stories became apparent.

By the middle of the nineteenth century this hodgepodge of influential antecedents lent narrative energy to the writing and publication for children of stories that intrigued and amused as well as instructed. As the Industrial Revolution swamped the British Isles with disposable income and leisure time, the English middle class swanned in and settled itself in parlors. And some lucky children, freed of the need to help on the farm or work in mills or beg, turned to books instead.

As a watershed moment, a magnificent example, you could hardly do better than settle on the publication of *Alice in Wonderland* in 1865. Here was a wildly comic, quirkily irrational dream-tale that offered readers no improving sermons, no cautioning and wise adults, no concluding couplet of morals to drive home a pedagogic point. (And it remained for forty years one of the best-selling children's books on both sides of the Atlantic, inspiring L. Frank Baum, among others.)

Grim grannies from the rural outback pursed their lips. They had understood childhood to be the proving ground of young sinners. In more secure industrial economies, those beliefs began to fade. Instead, an equally suspect notion of childhood as a trouble-free paradise gained currency in the popular arts. In one form or another, sometimes called the cult of childhood, that vain and decadent notion of childhood as untarnished by woe, unburdened by self-consciousness, persisted past Victorian times and thrived in its Edwardian, Peter Pan–ist, Pooh-ish heyday.

Consider the Lost Generation of the First World War: If modernity painted life as barren and arbitrary, cruel to the point of absurdity, even irredeemably meaningless, the childhood that one had left behind loomed in one's memory as even more sacrosanct and safe than it had seemed in the living of it. So the myth of childhood as Eden was still prancing about a decade after the Second World War. Indeed, though largely uncredited, such authority of innocence lent license to the generation that came of age during Vietnam. My generation. We conferred our own brave and sometimes silly hopes to the countercultural movements that protested the war and (while we were at it) claimed all sorts of verboten liberties as our own rights, too.

Lots and lots of good children's books were written in the century leading up to the 1960s. If light was shed on the peril and the promise of human existence, however, it occurred only rarely in picture books. Novels could admit to bitter truths—Kipling's and Mark Twain's managed it as well as any—but besides the works of Beatrix Potter and de Brunhoff and a few others, picture books generally preserved the banal sanctity of the nursery, where the green baize door to the grown-ups downstairs closed out anything unsuitable that might trouble the innocent mind.

What Sendak has contributed, before, during, and since the wild things, is a child's grammar of narrative and image sturdy enough to convey the anxiety and adventure, the danger and potential reward of the mortal world—a grammar that can be deciphered by a child too young to read.

I've written elsewhere about the how of it. This from my *New York Times Book Review* article on Kushner and Sendak's *Brundibar:* "One might say that in the Sendak oeuvre, books come in two basic types: the portfolio and the storyboard. Remember his *Nutshell Library?* Comfortably housed in a keepsake box are four tiny instructional volumes. Despite thematic coherence, there is no need for pace and accumulation in a portfolio—a book can be a set of discrete moments to be unpacked and regarded one at a time, like a set of nineteenth-century engravings of the wonders of the world. Look at this wonder! And this!"

I continue: "It is in the other sort of book, though—the storyboard, or the animated frieze—that Sendak's groundbreaking work has been achieved. The famous picture books, including *Where the Wild Things Are* and *In the Night*

Kitchen, derive their energy from early-twentieth-century popular culture: funny pages, cartoons, silent movies with their flickering captions and stagy gestures. In the picture books, progression is paramount; Sendak's protagonists float and drift and shift their shape. The careful integration of artwork with the poetically succinct text in a seamless page design is Sendak's forte and his contribution, and to date no one has bettered him at it."

That's the how of it. But why? Why would a man with Sendak's gifts spend most of his life in the realm of children's books? (Any of us who are caught up as professionals working with children and their books ask ourselves the same question.) One answer was voiced by Erik Christian Haugaard, the novelist and translator from the Danish of the fairy tales of Hans Christian Andersen. Haugaard said, "The fairy tale belongs to the poor . . . I know of no fairy tale which upholds the tyrant, or takes the part of the strong against the weak. A fascist fairy tale is an absurdity."

This is to say, I think, that children by dint of their youth are a minority population in more ways than one. And the best children's stories ring with that truth in apparent or underground ways.

Leave aside the quirky elegance of Sendak's graphic rendering, the steely perfection of play between art and text, the psychological and, some say, mythopoeic narratives tricked out as stories for children. Throw all that aside. Sendak's nursery sagas are worth very little without a steady and unflagging creed: The weak and lowly are not to be abused. And though the lowly may not ever stop being lowly, they may also not be as weak as they seem.

◆

Archibald MacLeish said, "There is only one kind of poetry: Poetry. The art has no departments."

I work in the shadow of MacLeish's statement when I choose to forgo dissecting a single Sendak book in its entirety. However many reproductions I might supply, illustrations taken out of the apparatus of the individual bound book can never convey the bookishness of a book, the pace and scale and satisfaction and completeness of it, no more than a fish scale can substitute for a real, live unblinking carp, or a slice of honey-glazed ham can suggest the respectable professional pig.

Hence my decision to approach a life's work as if it were a single creative act and to concentrate on a presumed internal consistency. So, to showcase a wide range of drawing and painting styles, to flip through Sendak's pattern book as it were, I'll consider some—only some—of the types of images that recur in book after book, whether their texts were written by the artist himself or by others.

I've chosen a sampler of four motifs as a way to suggest theme and variation, range and repetition. The categories include flying and reading, children and other monsters. When we convene in 2028 for the hundredth anniversary of Sendak's birthday, we might consider the occurrence of sunflowers, babies, caves, lions, eating and regurgitation, hooded ghouls, music, dogs, and blackbirds.

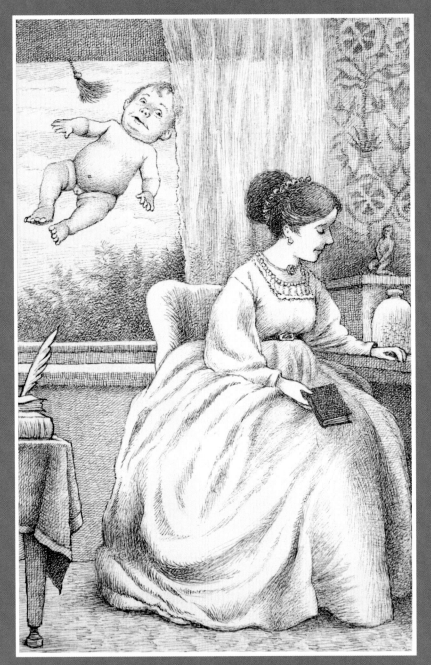

What is it about flying that is not just essentially Sendak but such a key into fantasy? The possibilities inherent in hope, anticipation, untethered dream? The dream journey starts in infancy, surely—though the mother contemplating her book, in this Vuillardesque composition, is hardly less dreamy than the daughter making her maiden voyage . . .

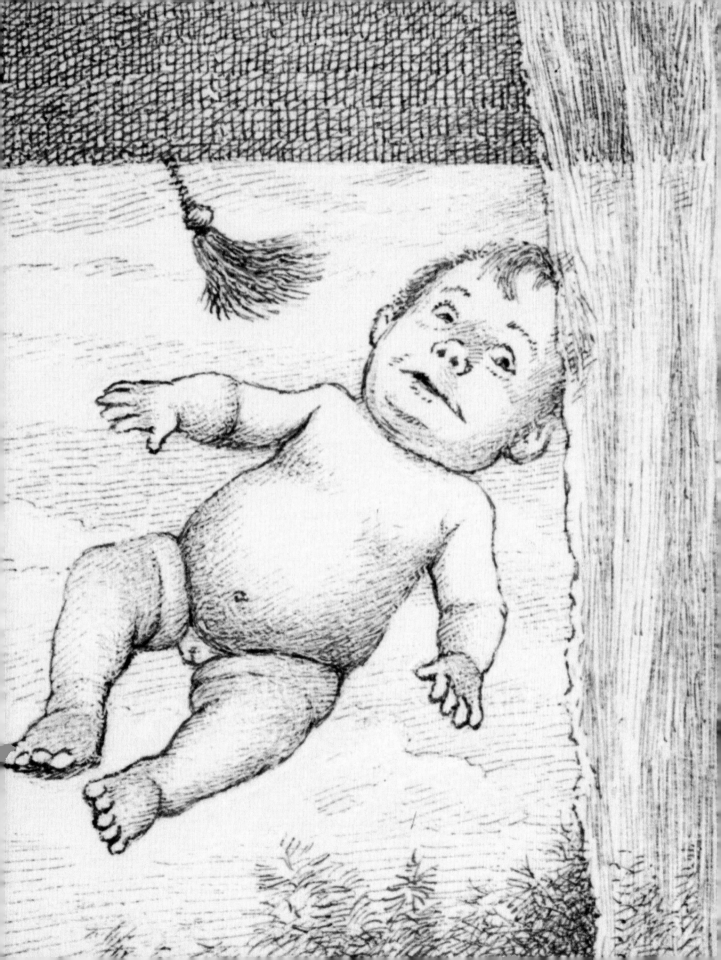

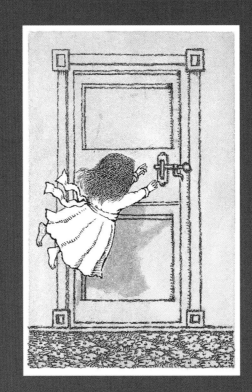

Flying is
desire fulfilled.

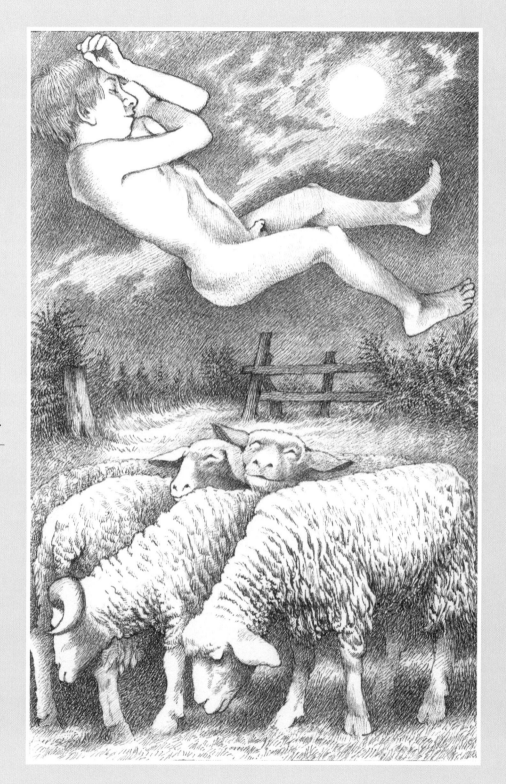

Flying is
sweet release.

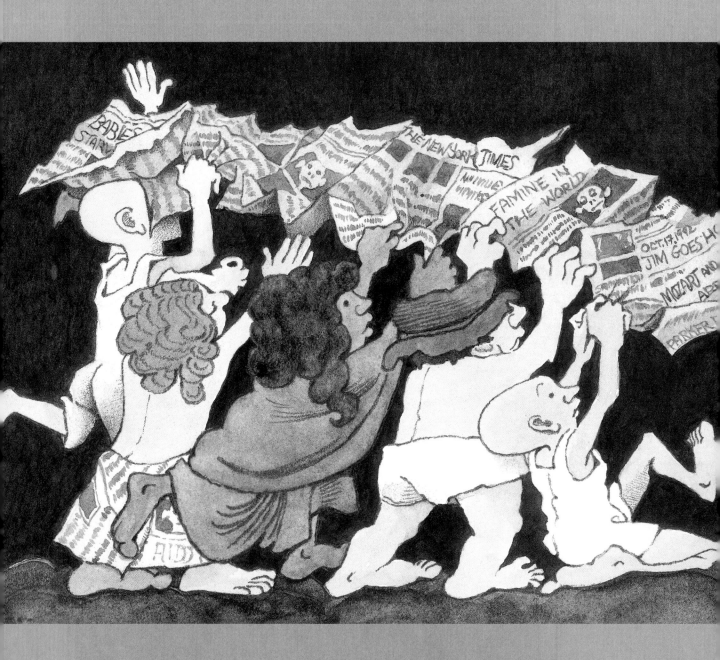

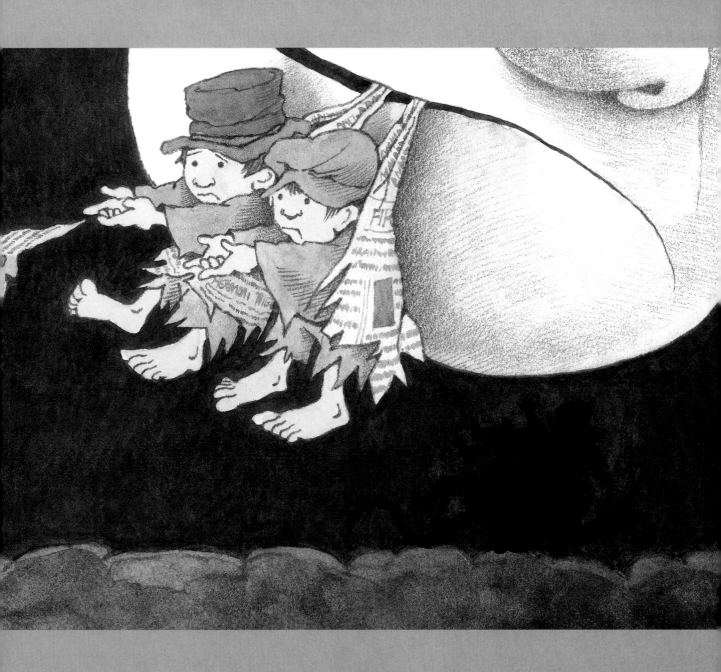

Flying is rescue.

Flying is confidence.

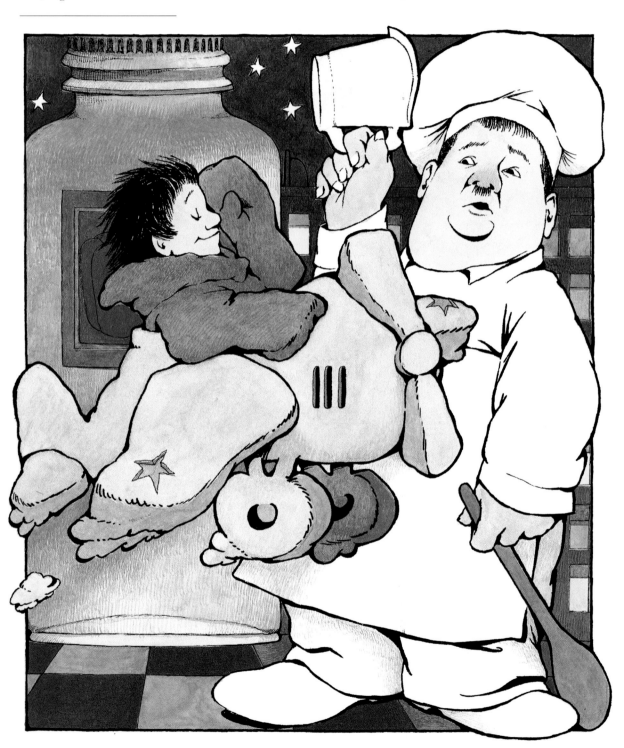

Flying is disconnectedness:
Escaping obligations can be akin
to drifting unmoored....

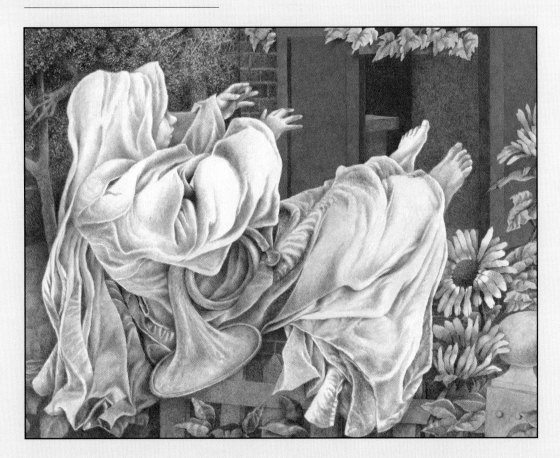

Connectedness returns through
the magical agency of art: Sometimes
music (wonder horns, the inalienable
drum-thud of a wild rumpus, a
Scottish hornpipe, a tidily small but
boisterous orchestra), but, suitable
coming from an artist of folio and
frieze, consolation just as often
arrives through the agency of books.

B ooks with their power to anchor, to connect, to amuse . . .

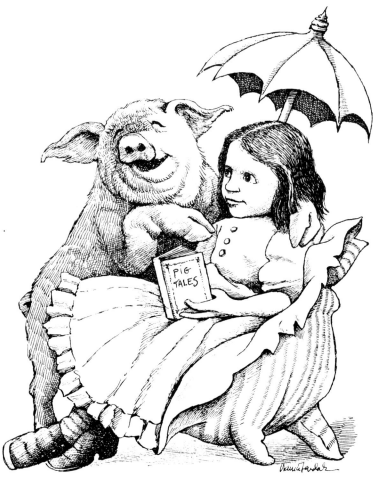

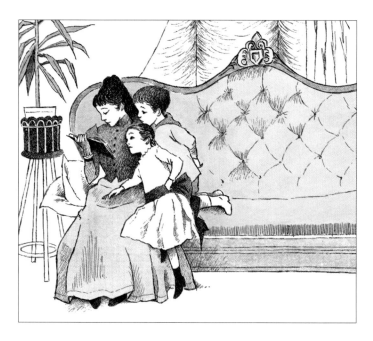

and to distract;

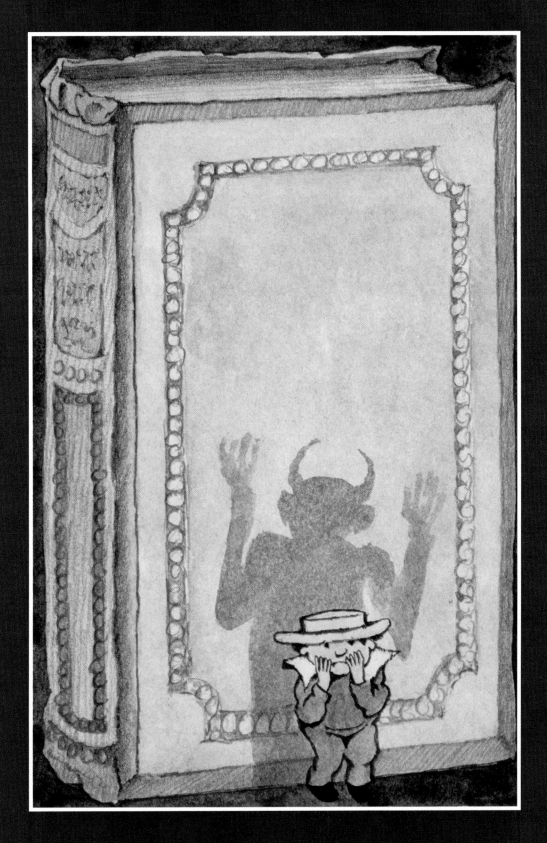

to terrify . . .

to unite
adversaries
in détente . . .

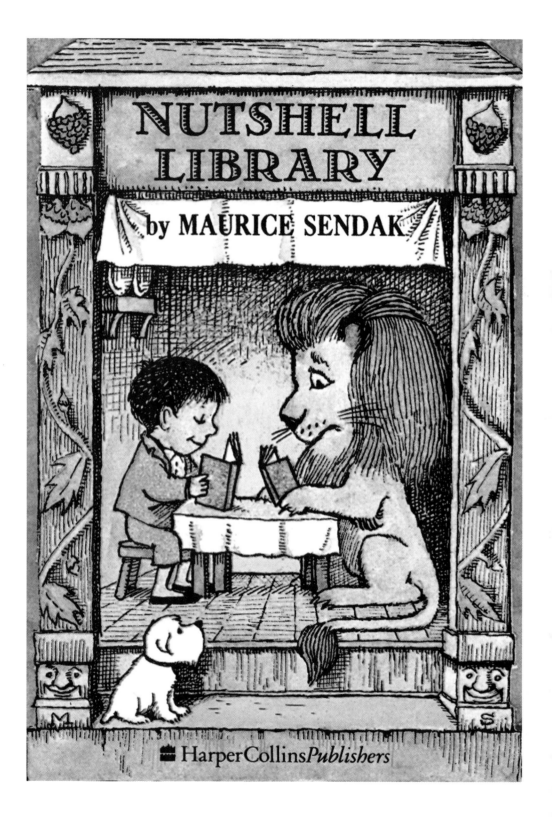

A book
is to look at

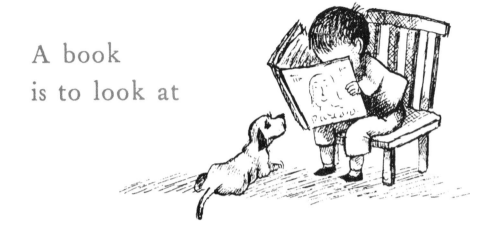

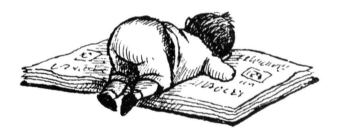

and to offer a little
rest for the mind
and the body.

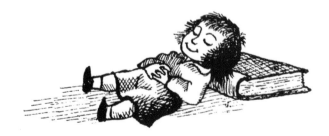

And in those very books? Ah, family portraits: ancestors and descendants of the wild things, creatures menacing and benign:

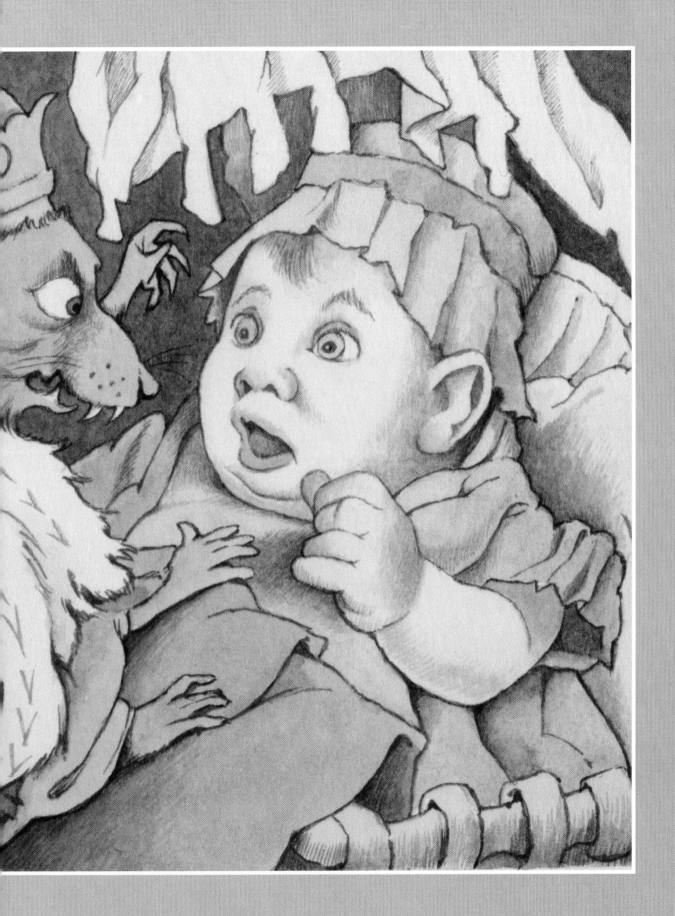

A wolf, from *The Magic Pictures.*

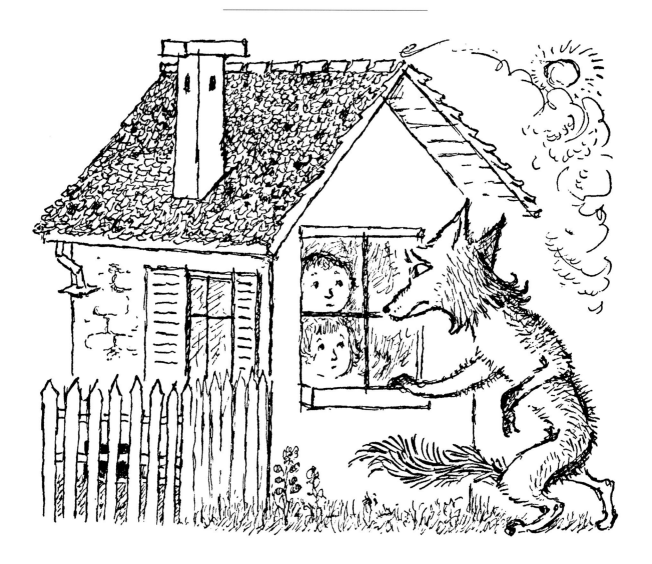

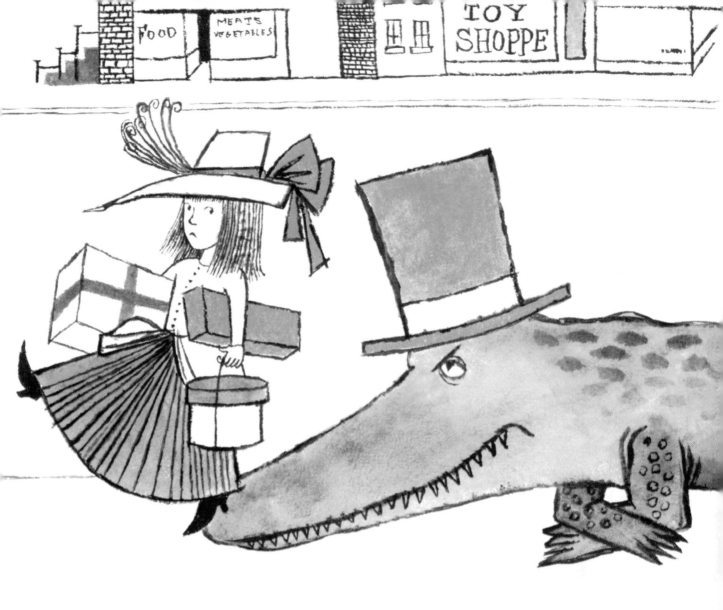

An alligator, from *What Do You Say, Dear?* (Someone clearly left the house backward out her window, and is about to make a serious mistake.)

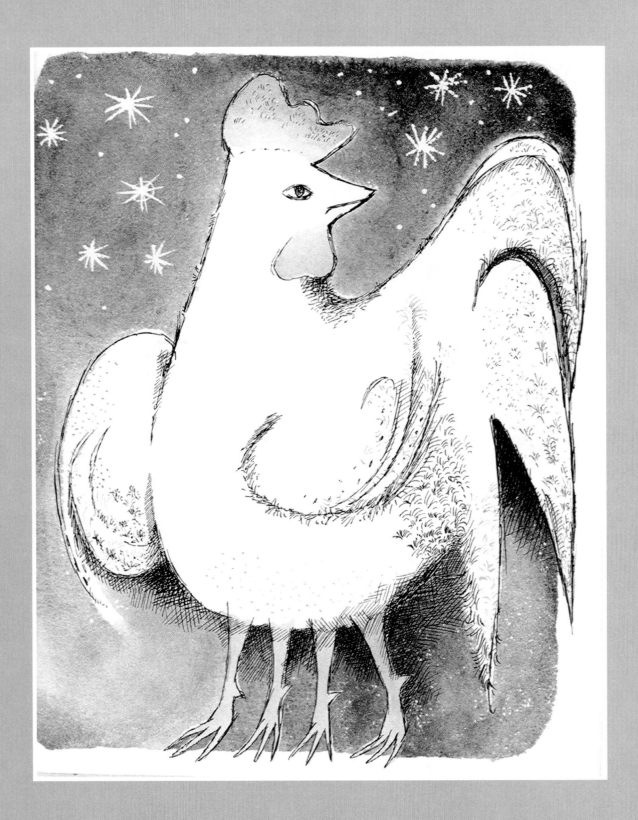

The Chagallesque
four-legged rooster from
Kenny's Window and an
upscale version, done
several decades later.

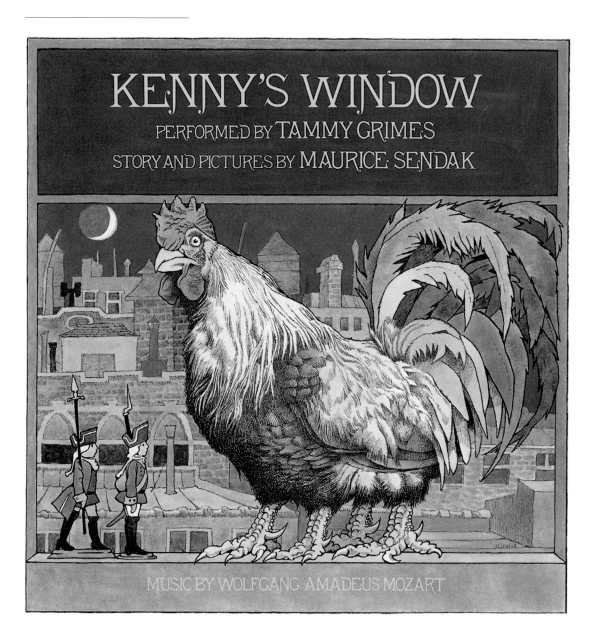

KENNY'S WINDOW
PERFORMED BY TAMMY GRIMES
STORY AND PICTURES BY MAURICE SENDAK

MUSIC BY WOLFGANG AMADEUS MOZART

Here is the Griffin, from *The Griffin and the Minor Canon*, emerging from a cave that closely resembles the cave in *Where the Wild Things Are*, published in the same year (a cave, incidentally, identified by Sendak as possibly being inspired by the cave from which King Kong emerges).

Behold the dragon from *The Bee-man of Orn*. (I'm reminded of a line from Günter Grass's *The Tin Drum*: "... Innocence is comparable to a luxuriant weed—just think of all the innocent grandmothers who were once loathsome, spiteful infants.")

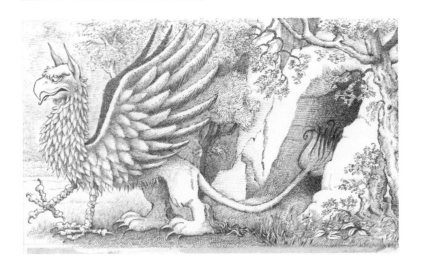

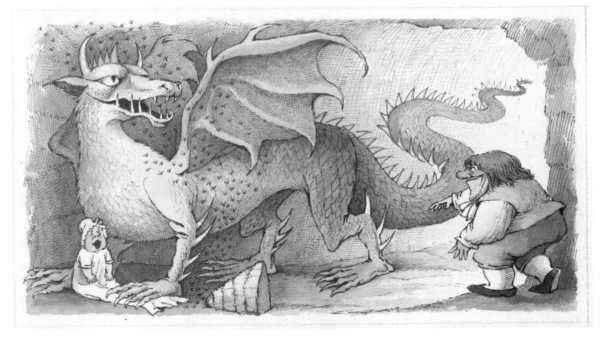

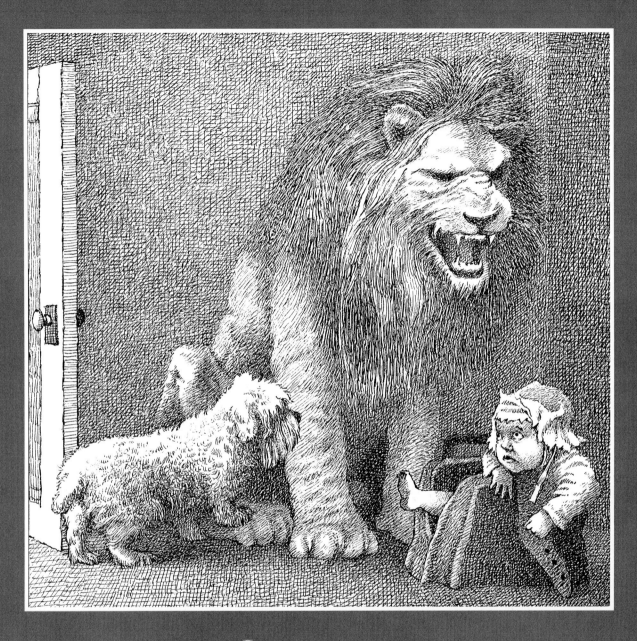

Jennie, the Sealyham terrier, is the hero in *Higglety Pigglety Pop!*, but which one is the true tyrant, the lion or the baby?

And is the Nutcracker more
dashing or more dangerous?

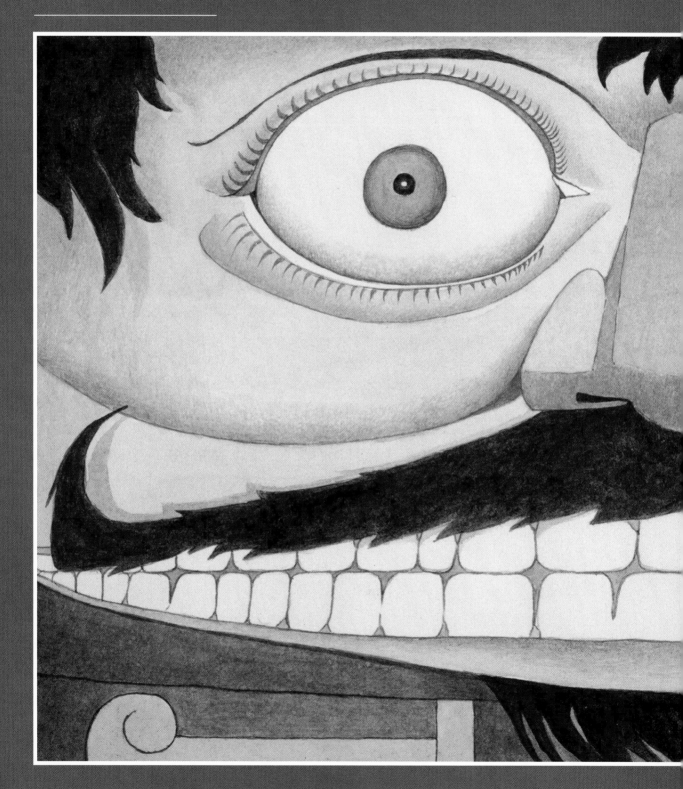

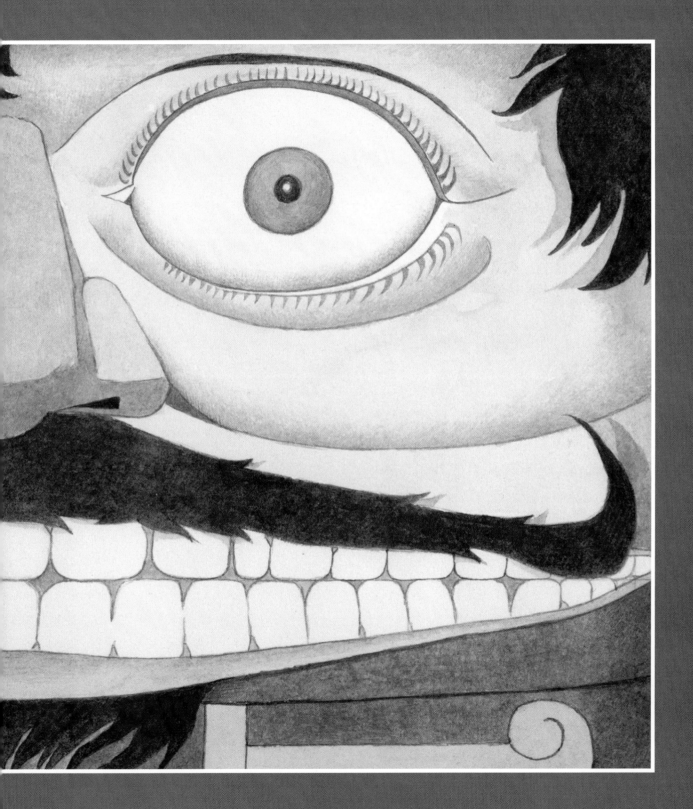

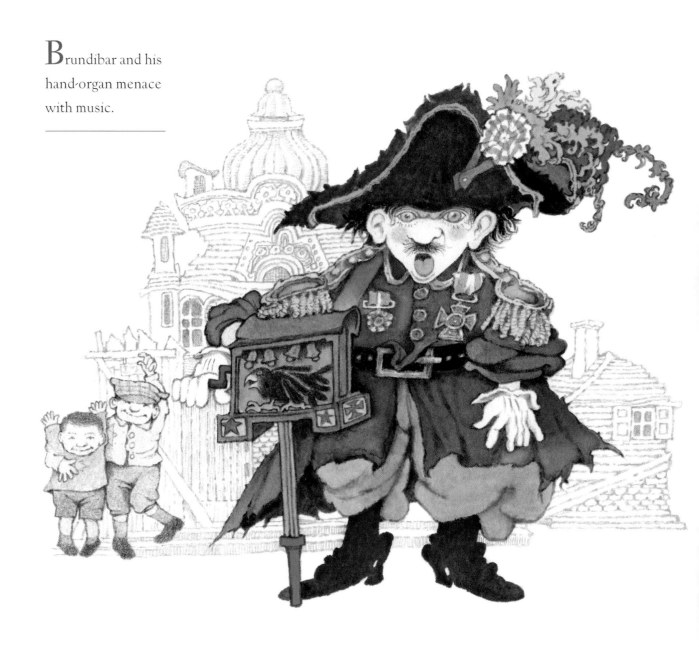

Brundibar and his hand-organ menace with music.

The witch from *The Light Princess* has something in mind, and so do the hooded phantoms from *Pierre* (overleaf) . . .

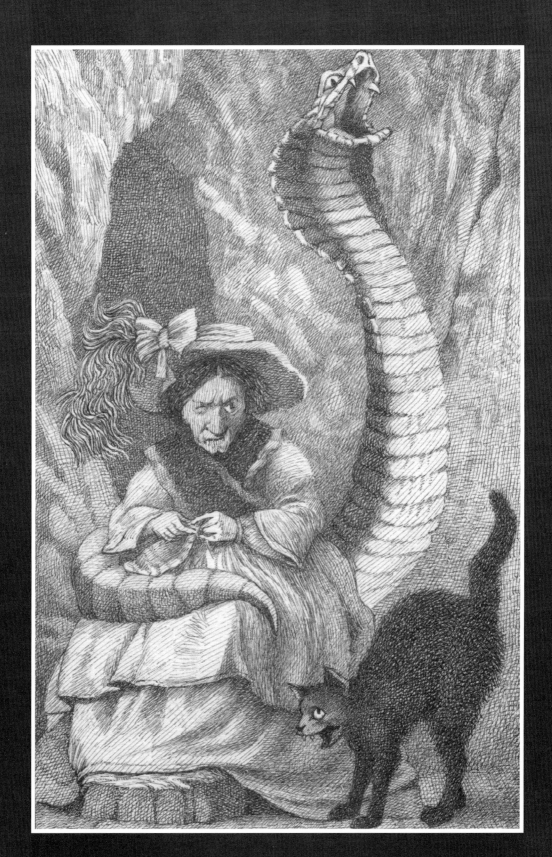

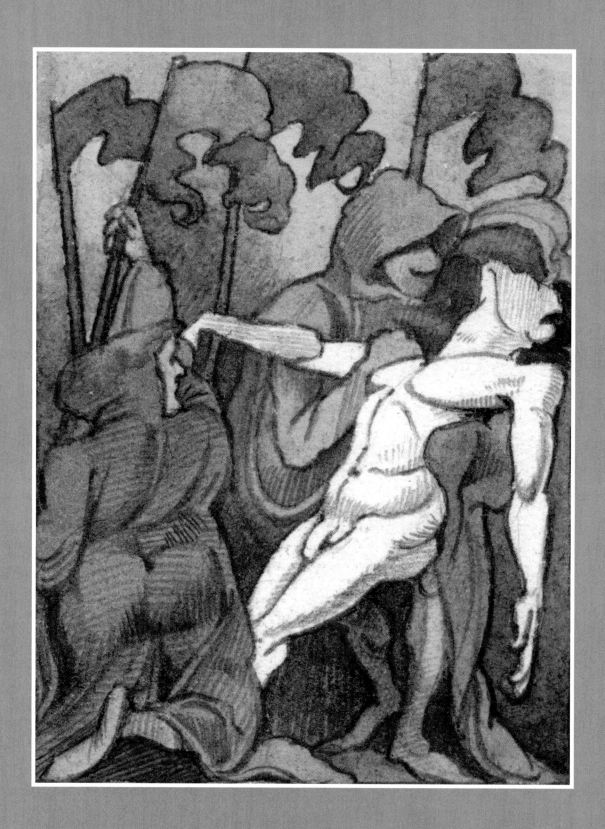

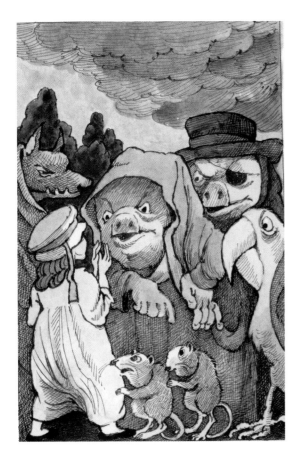

while these creatures from
I Saw Esau, who seem like
the more aggressive of that
rabble from Wonderland, are
about to turn nasty on this
unfortunate trespasser.

Flying, books, monsters: In each of
those categories a relationship is implied
between the impossible and the possible.

However, there are matters more
important than the genetic resemblances
of clan members across the pages and
across the decades, the familiarity of
inherited traits, the expressions and habits
and gaits. More fundamental to Sendak's
work, for over fifty years, is his trust in
the validity of the emotions of children.
It's in this area that he has demonstrated
his widest range. And please note that
almost none of the images that follow
are renderings of the impossible or the
fantastic, except, of course, that emotional
currency itself is impossibly fantastic,
especially to children.

I might have chosen any baker's
dozen of drawings, but to limit my focus,
I selected pictures to illustrate such
emotions to which young people are
particularly prone.

Glee . . .

apprehension . . .

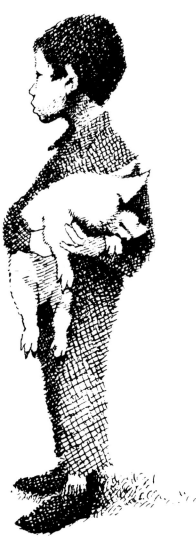

irritation . . .

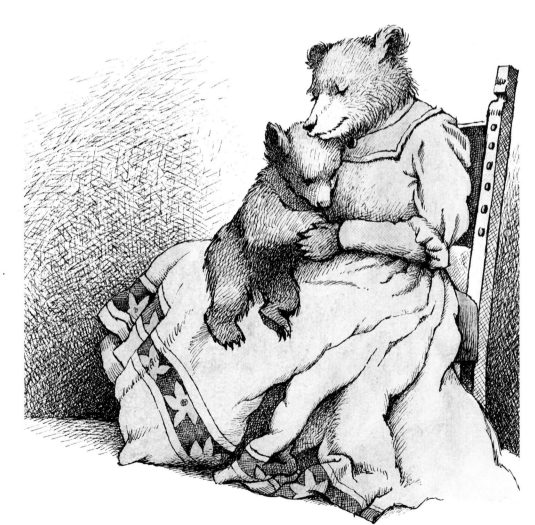

and consolation . . .

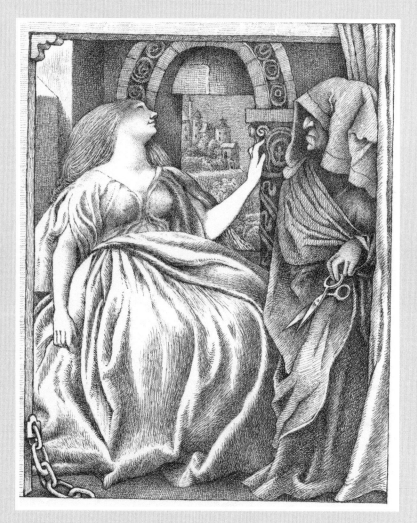

sensuality . . . and abandon.

That's not all; on we go, pushing through swamps of grief . . .

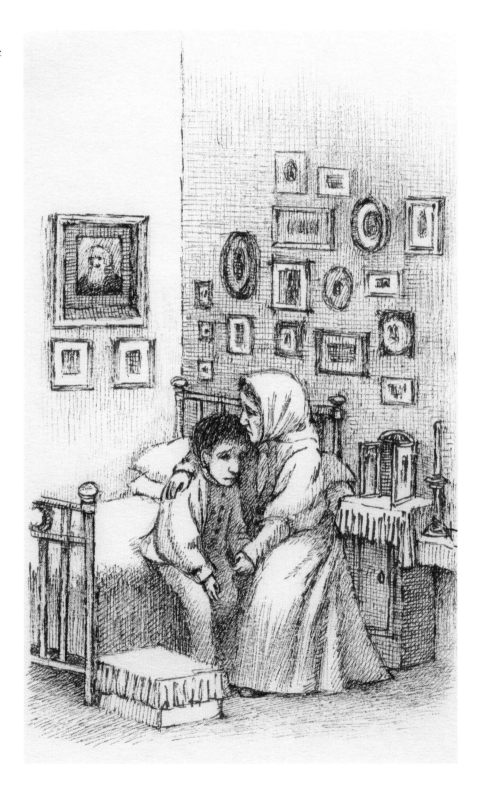

and oases of friendship;

refreshed by fraternity, whose
scratchy village backdrop evokes
certain Rembrandt drawings;

and at times subdued: here,
a Ben Shahn sort of desolation.

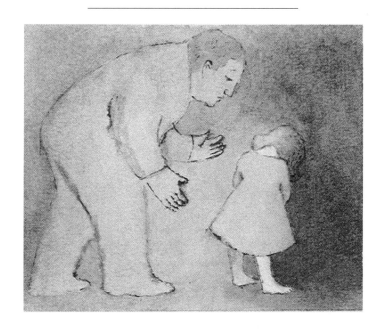

Not to mention the rewards conferred
by the Conservation of Inner Resources,

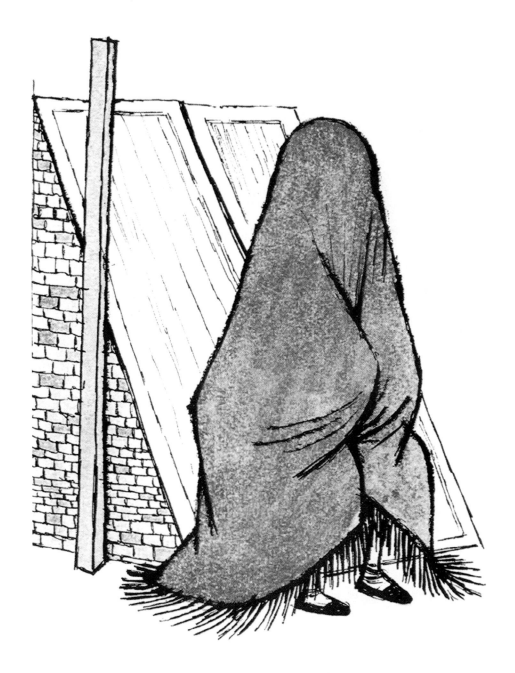

the satisfaction of creativity,

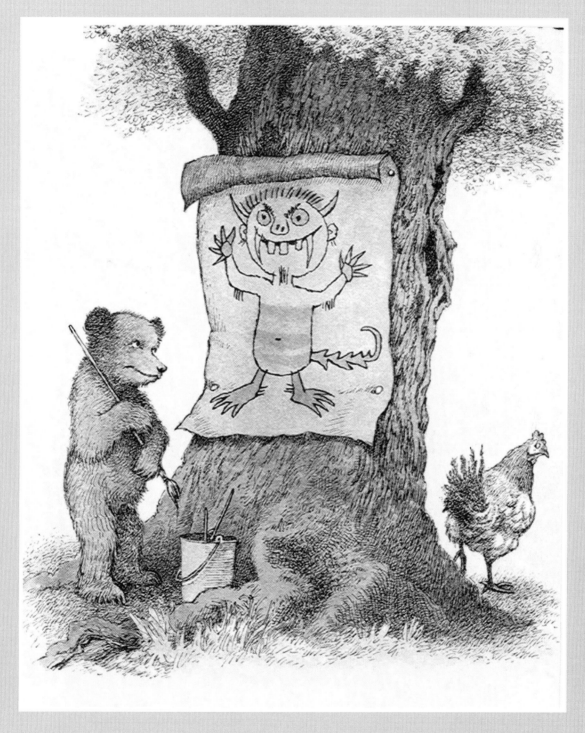

the lovely danger of passion.

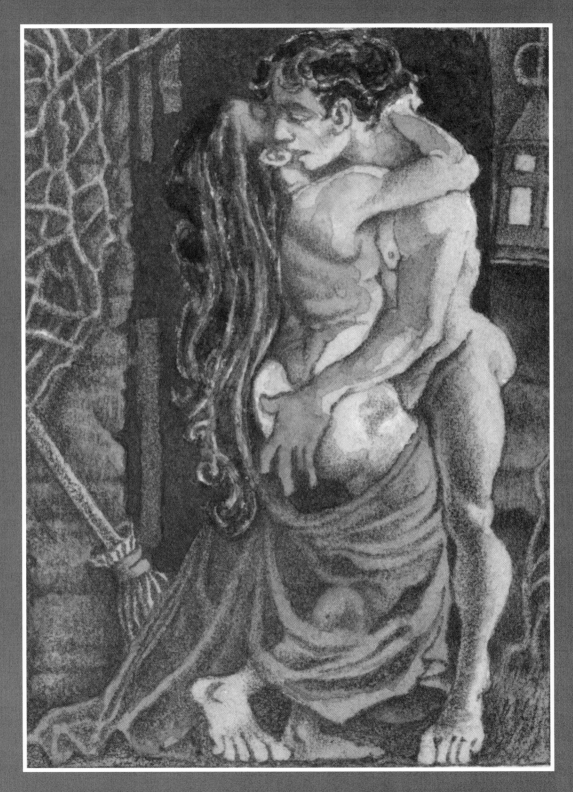

Desolation over the first
intimations of mortality

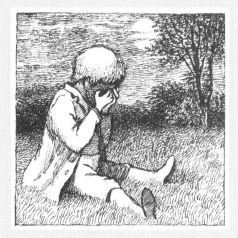

is cousin to elation at
considering transcendence.

————————————————

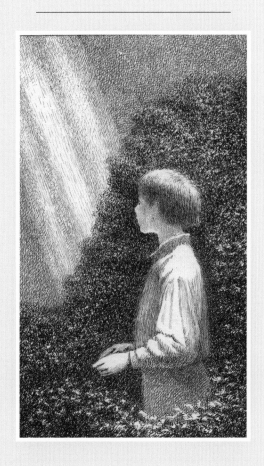

I have said that I won't venture to name an overarching theme in Sendak's oeuvre, and I mean to keep my word. And this book is not a public reading of an artist's work as a Rorschach test. Yet the famously private, sometimes curmudgeonly artist has spoken recently with an uncharacteristic directness about the impact on his childhood and development of his personal situation: growing up a sickly Jewish kid in Brooklyn while relatives abroad were being hounded out of their livelihoods and then their lives.

He doesn't need to tell us this. He provides abundant evidence on nearly every page. The limbo is real. The fight for transcendence—the artist's fight, the soul's angry battle for it—is real. The moon looks down on the quick and the dead alike.

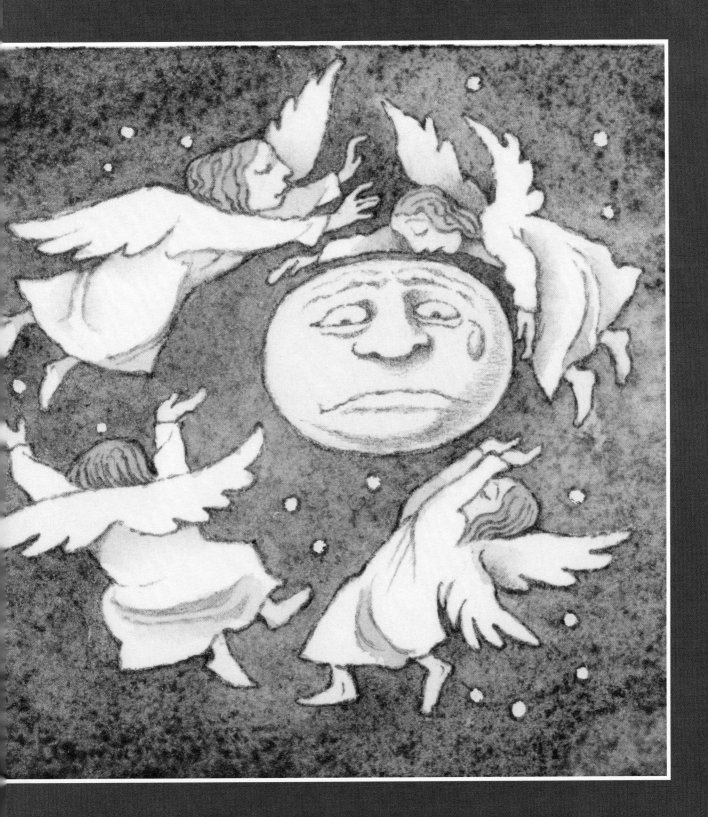

[3]

IN THE ILLUSTRATIONS FROM the preceding section, we can't help but appreciate a wide range of styles and effects. The earliest pictures date from 1954 and the most recent ones from 2003.

What unites these disparate styles, media, subjects? What is constant in the artist's half-century output?

For one thing, Sendak often presents a studied artificiality of background, spending little effort at verisimilitude. What do I mean? His graphic anarchy begins with slightly cubistic architecture, where the planes of the buildings won't resolve according to strict Renaissance laws of perspective. Windows reveal figures too large to fit inside the implied room within. Backgrounds—in works like *In the Night Kitchen* and *We Are All in the Dumps with Jack and Guy*—unscroll with a common likeness, page to page, but without repetition: Things are subtly different each time they're drawn. We pause, we recognize; we try to work it out.

The everyday world remains solid and reliable. Max's bedroom looks the same at the start and the finish (save for the bowl of supper that has arrived). Mickey's bed is comfortably monomorphic. But in the meat of the story, during the adventures, the world bucks conventions and refuses to be tied down.

It resembles the universe of Krazy Kat and Ignatz Mouse: Coconino County, endlessly identifiable as itself, but never, ever, ever the same panel to panel.

The nearest analogy to this resistance to hammering down the spinning compass rose of the dreamworld is, perhaps not surprisingly, from the Alice books. The Mad Hatter and the White Rabbit from *Alice's Adventures in Wonderland* make a guest appearance in *Through the Looking Glass*, but their names are different. The White Rabbit is called Haigha (hare—pronounced "so as to rhyme with 'mayor' "). The Mad Hatter is called Hatta. The extraordinary Tenniel completes the association for dubious young readers by rendering Hatta capped with the same hat worn by the Mad Hatter, the same card reading the price of ten and six stuck in its band.

Alice is drawn standing with her hand on her mouth, trying to work it out: A dream reference is so insubstantial. She never brings herself to ask. Later, as Hatta goes bounding away, "for a minute or two Alice stood silent, watching him." She's almost there, she's almost got it . . . but the madness of life whirls up again before she's solved the puzzle. What do dreams *mean*?

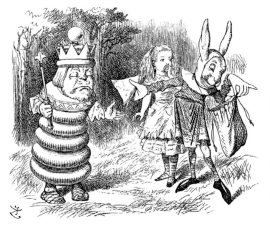

Sendak uses a similar dislocating visual trick in how he renders supporting characters. Many of his books include clots of characters who resemble one another but who serve a sort of Greek-chorus function. The baby goblins haunting *Outside Over There* are indistinguishable one

from the other. So are the three Oliver Hardy bakers from *In the Night Kitchen*. Except for Jack and Guy and the poor little kid, the street urchins from *We Are All in the Dumps with Jack and Guy* hail from central casting: There's no one of them on every page. They come forward out of the background and play their part in the tableau of one page, and disappear on the next. They are a type, not individual. Take the wild things: The horned one with the mane of hair is perhaps the most famous, and certainly recognizable, but even he doesn't appear on the page where the wild things roar their terrible roars and generally carry on disgracefully.

In addition, Sendak avoids absolute opacity in the application of media. The translucency of his wash work and crosshatching, with few exceptions, honors and acknowledges the presence of the paper. There's no attempt made at trompe l'oeil.

As in medieval and Renaissance frescoes and paintings, a profound significance obtains in how Sendak places his figures in their frames. However gritty the subject matter, we never get cinema verité from Sendak: We get studied *tableaux vivants*, in which each composition is compressed for maximum impact. Notice, almost universally in Sendak's work, a shallow depth of field, where the main action of the page, the drama being pictured, is seldom more than an implied eight feet deep.

You might say the figurative depth is about the width of a traveling stage. Or maybe the distance between the curb and the front door at the top of the stoop.

It's a point worth belaboring for another moment. Historian J. R. Hale, talking about Renaissance Europe, remarks, "There was a comparability of effect . . . between the *tableaux vivants* of actors posed against a painted background which were dispersed along a pageant route and the way in which painters placed their characters—in an Annunciation, a Birth of the Virgin or a Last Supper—in an enclosed space. The feeling for unity and enclosure is very similar. In all likelihood the feeling for unity of setting had originally passed from painting to the stage, but it is possible that an interest in psychological realism had passed the other way, that painters had been aided in their expression of grief and anguish by watching actors."

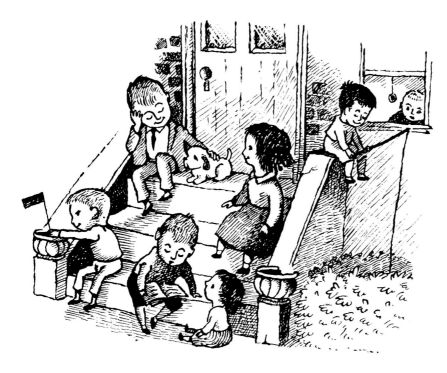

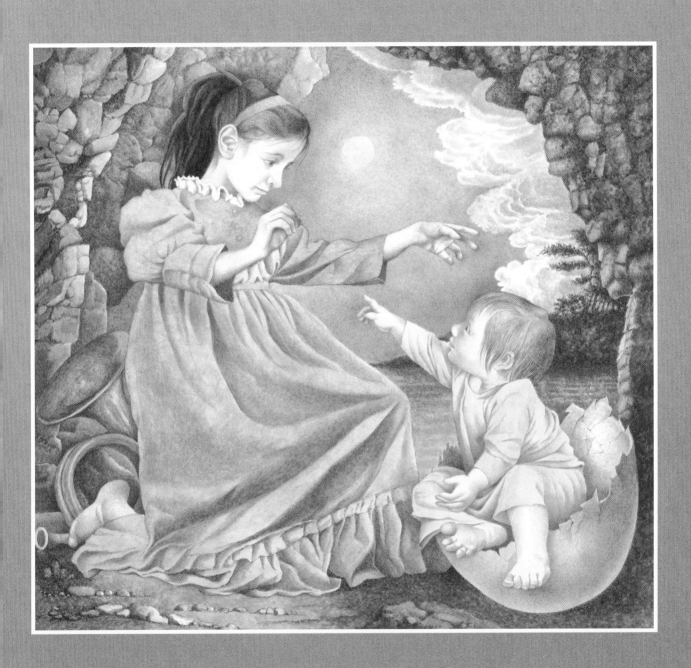

The shallow playing field depicted in Sendak's work— how little effort is spent to make two dimensions pretend to be three—is further enhanced by Sendak's well-known interest in the performing arts. Music is not least of them, but drama and melodrama pertain, too. Let us remember the significance of the proscenium arches in Sendak's work—starting with the many windows that frame the world (and the similar stance and mood of those caught inside): starting from *Hurry Home, Candy* . . .

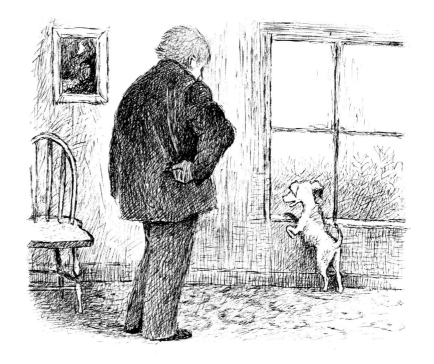

to Kenny's window . . .

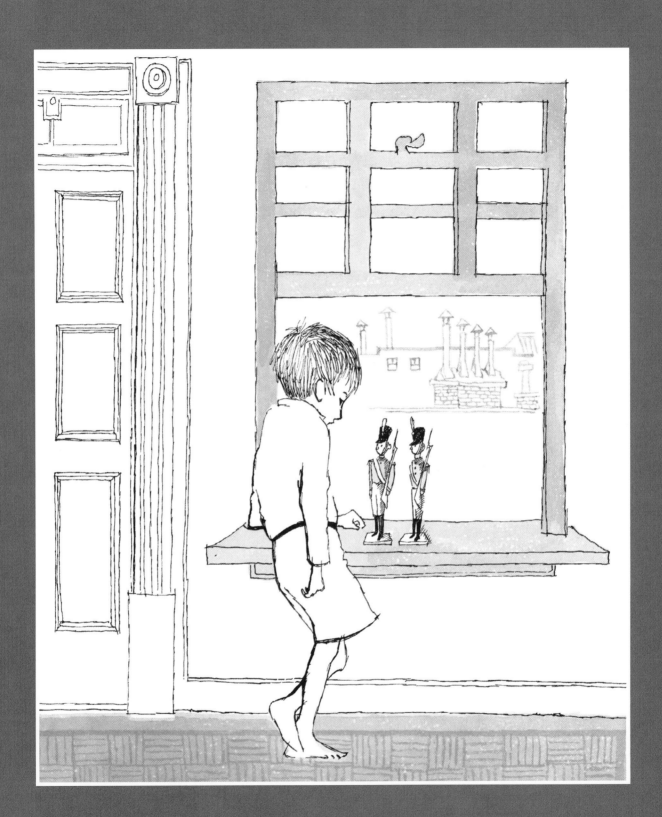

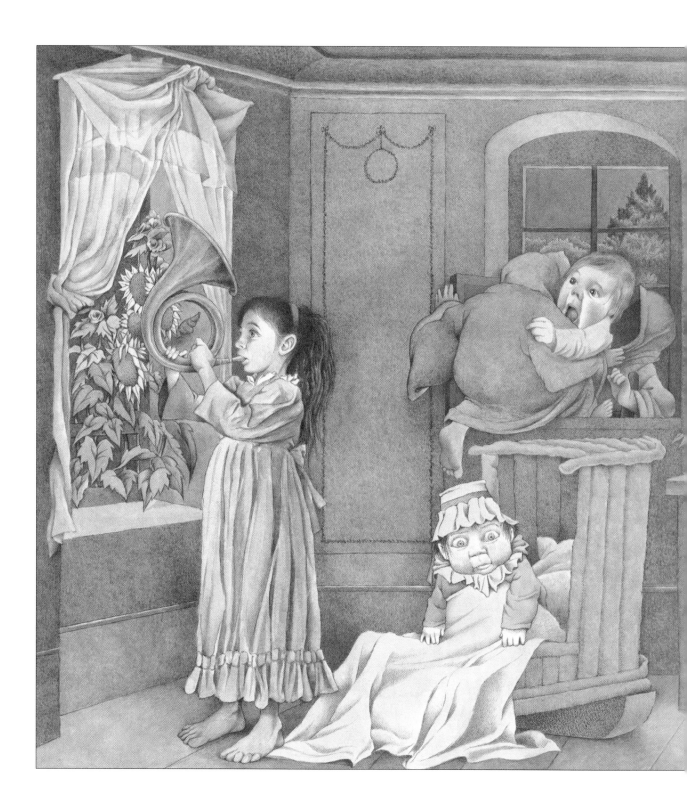

to Ida's window, and on through to Jennie's window . . .

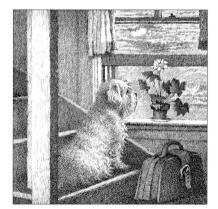

concluding, most
obviously, with
the World Mother
Goose Theater
stage, the window
through which Jennie
performs her nursery
rhyme knockout role.

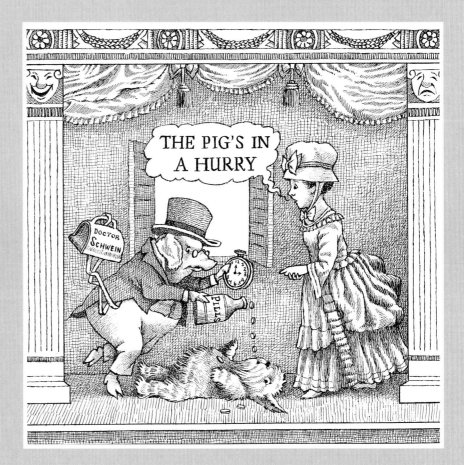

In time we become
bedazzled by the cross-
referentiality, the
intertextuality of it all; the
entire oeuvre begins to seem
Borgesian, or Escheresque,
or Calvino-ist. Certainly
dreamlike, but never quite
nonsense.

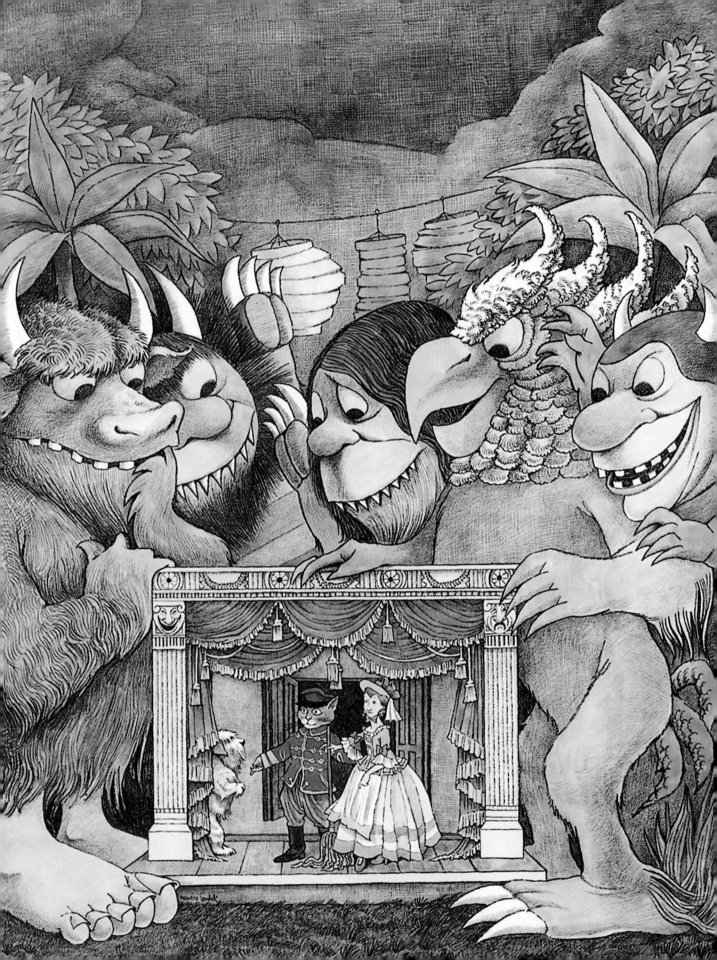

Across his career, Sendak's recognition of the page as stage seems to emerge in, well, stages. Consider the looseness of the page of some of his early works, particularly for Ruth Krauss, where the egocentrism of the child is unbounded. In one instance, the child is the center of anarchy; in the next, the child is the center of a shapely narrative. But it all begins and ends on the same page.

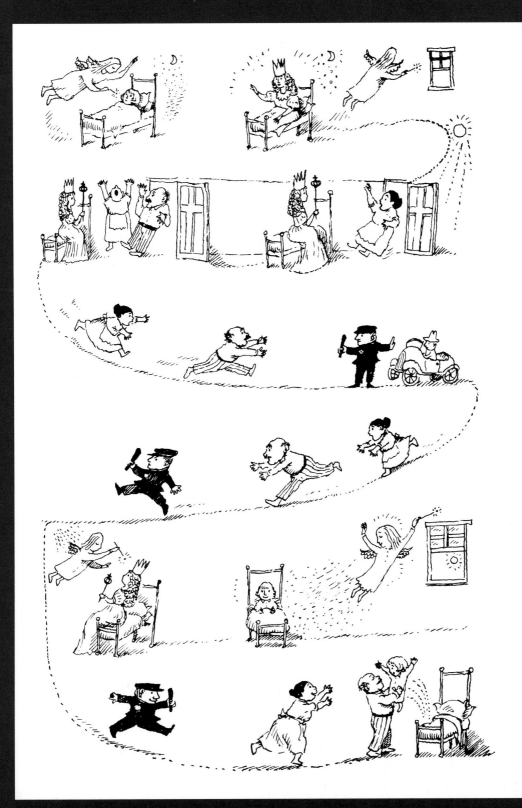

Before long Sendak is using the entire page for the depiction of a single moment, bleeding the image off the edges. The page's restrictive rectangle used as a window frame, a proscenium, heightens his inclination to stage-manage his figures. Once this happens, the anonymous figures begin to gel as character actors, and Sendak acknowledges the artificiality (and the great fun) of nudging performers through their paces.

Think of the slipcase of *Nutshell Library*, where in happy silence, offstage, taking five, the protagonists peacefully cohabit space in the greenroom, waiting for their cues.

NUTSHELL LIBRARY

by MAURICE SENDAK

HarperCollinsPublishers

It isn't a far cry from here to the pair of nameless kids . . . the boy and girl from *King Grisly-Beard*, who approach a very Sendak-impersonating impresario and sign up for the job of acting out the story to follow. Are these kids Maurice and Natalie Sendak? Or Rosie and Max? Not sure. Doesn't matter. They get a lot of work and do their jobs well. For one thing, they appear in a lot of posters.

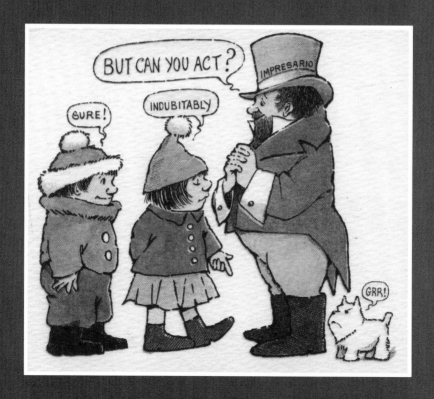

IMAGINATION

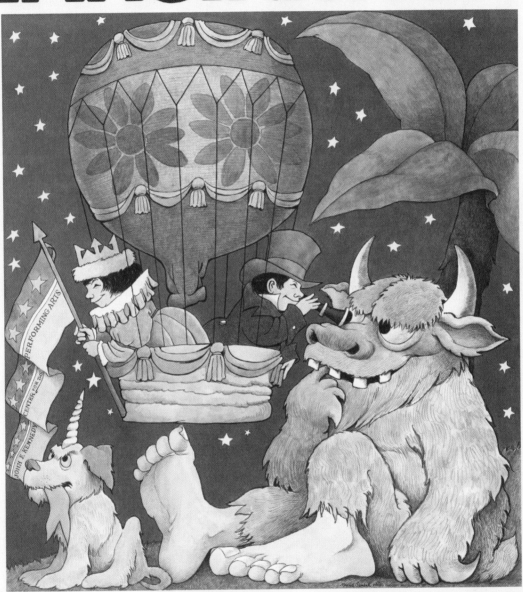

CELEBRATION

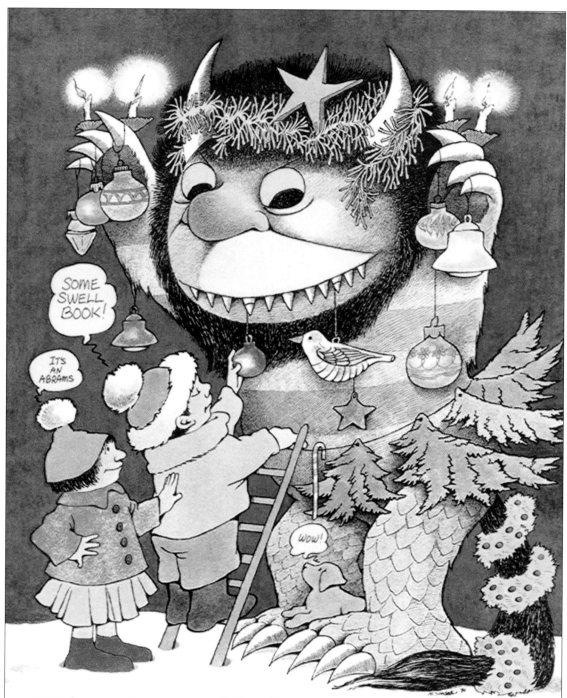

The Art of Maurice Sendak

MAURICE SENDAK'S CHRISTMAS *Mystery*

CHRISTMAS
MYSTERY
THIS WAY

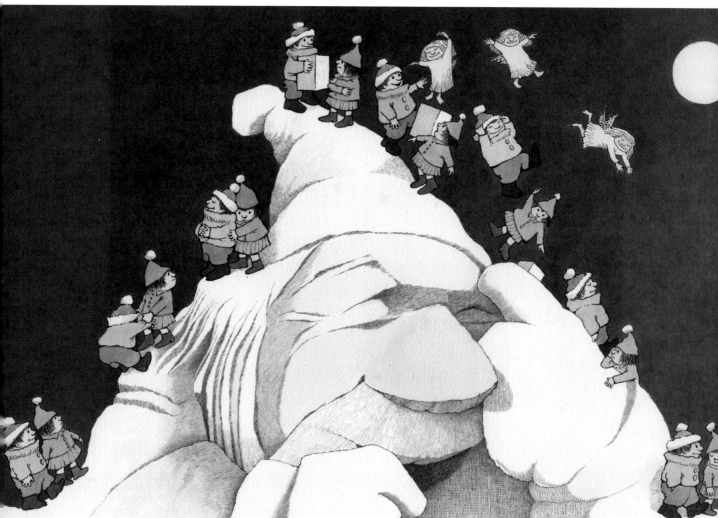

The characters become regulars in a traveling ensemble. Jennie, the wild things, the Oliver Hardy baker, the two kids, the lion, the moon, the hooded phantoms . . . Sendak is the impresario. He's Altman, he's Woody Allen, working with an all-star cast who'll do anything for him, anything.

Looked at this way, the late-blooming collaboration between Sendak and playwright Tony Kushner seems less bizarre than inevitable. Other commonalities of their identities aside, both men work in fantasy with far-reaching social overtones and undertones, and both are slaves to the performance of Dionysian revel (yes, I'm referring to theater and opera).

Sendak and Kushner's collaboration, *Brundibar,* is based on a Czech opera composed by a Jew, Hans Krása, and written for and performed by children incarcerated, as he was, in Terezin. The inseparable pair of siblings rollick through the cautionary fable, and each of Sendak's recurring tropes discussed earlier are employed—the magic of words (in this case sung lyrics rather than depictions of books), and flying, and monsters, and the unfathomable capacity of children to feel and *experience* their lives. It's a hurdy-gurdy of a tale, in which tatterdemalions and ragamuffins act out a morality play of grief and survival, and while it is not a swan song, *Brundibar* is a crowning achievement of a master dramaturg.

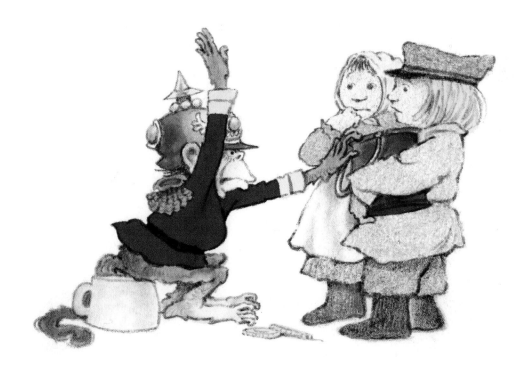

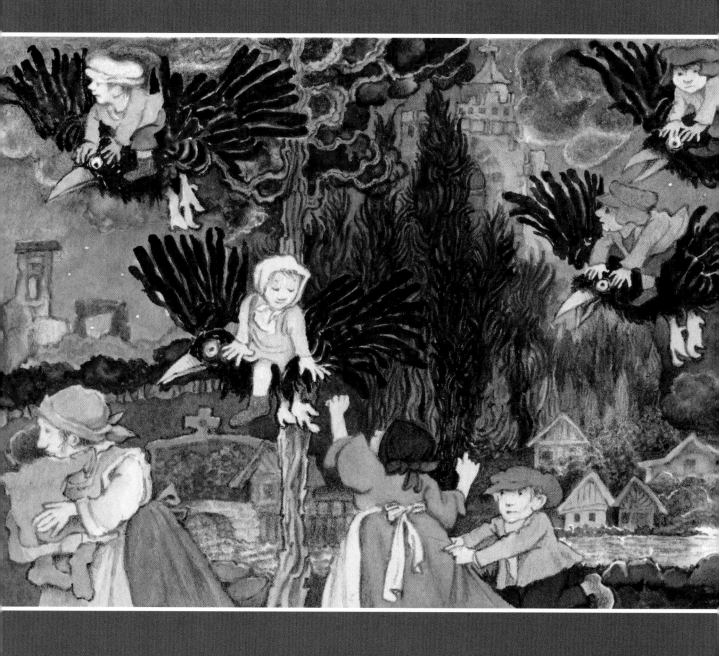

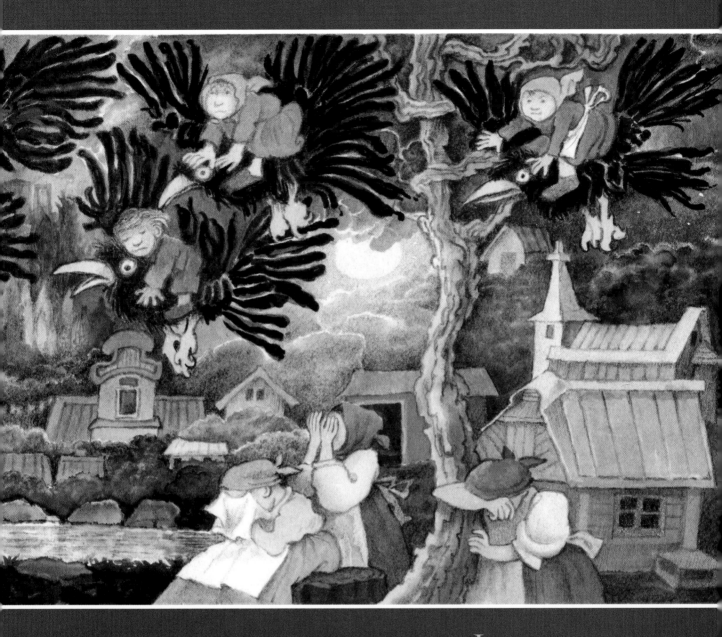

It comes to this, late in
Sendak's career: Mothers
weep while their children are
carried away on birds as black
as a moonless night.

[4]

IN THE MONTHS PRECEDING the exciting day I would present this piece to the public, when I had nothing else to worry about during the sleepless hours between dusk and dawn, I found myself lying awake in bed. Was it the call of my own muse, piping his encouragement?

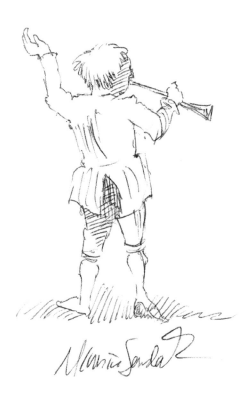

This is what I look like when I can't sleep. It's true.

I mean I look like the owl, not the gentleman.

I spent time puzzling over what a *Descent into Limbo* might mean to Maurice Sendak. My own descent, in that hypnagogic state in which one stirs fitfully without rest, was to imagine a dystopian world in which the advent of a new kind of virus, worse than anything we've yet seen, would wipe out all the printed books from homes and stores and libraries. All gone. Fahrenheit 451. Fahrenheit 1984. Fahrenheit 9/11.

I posed myself that most dreadful of midnight games: the roulette of contingency and disaster. Suppose all of Sendak's artwork were hanging in a museum on the corner, and the building caught on fire. You have the chance to save only ten pieces of artwork for posterity. Which ten do you save, dear?

What a nightmare!

In no particular order, knowing that these single images are all wrested without their consent out of the books and away from the words they serve, I struggle to decide: What would I drag from a burning museum?

———————————————

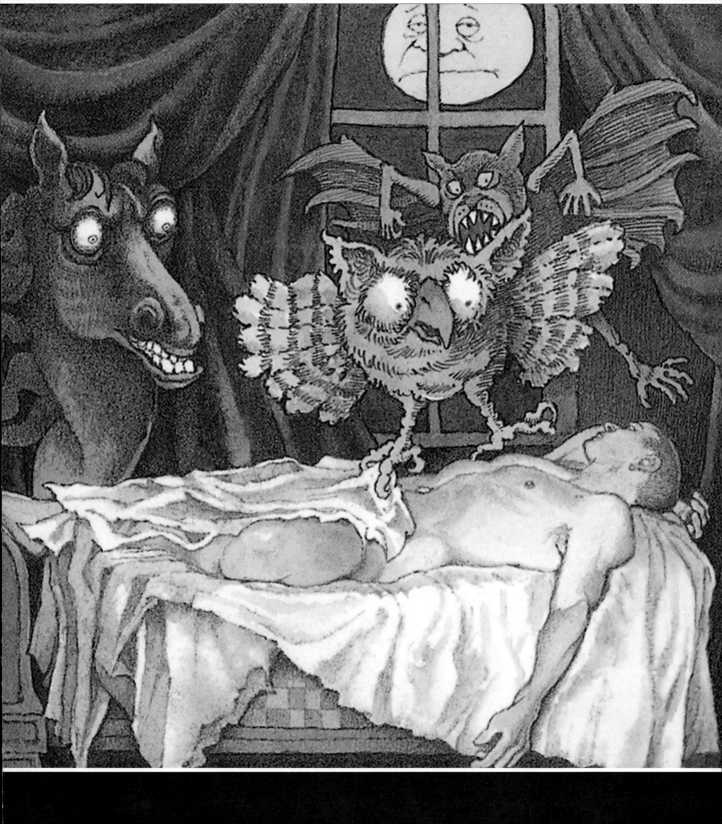

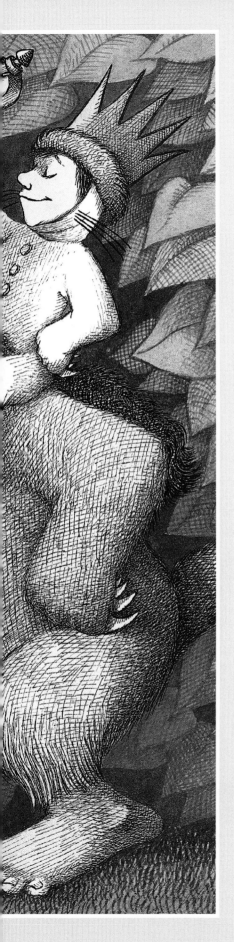

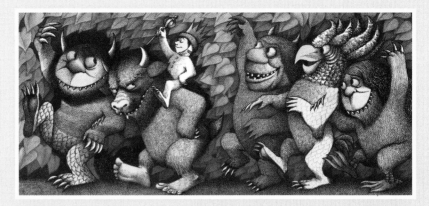

NUMBER ONE:
Where the Wild Things Are

The final spread of the three-page wild rumpus.

This third page occurs at an imprecise time of day or night. The leaves are clustered like those in a William Morris wallpaper run seriously amok. The quintessential wild thing leading the procession opens the parenthesis of attention with his right arm; the subservient final wild thing closes it with her left arm. The eggy yellow eyes are all trained on Max, who is too much in control to need to stare into their eyes anymore. His kingly mace is a musician's baton, setting the beat of the march, to which each beast leads with its right foot and leans on its left.

What delights the most, perhaps, is the undulating rhythm of the five forms of the wild things, the gentle contrapuntal zigzag of spinal armatures. This is a staff of music drawn in characters rather than notes. It orchestrates the return of the king. Max on the Minotaur, eyes closed in kingly power, is lord of limbo, lord of the otherworld, and lord of himself, all at once.

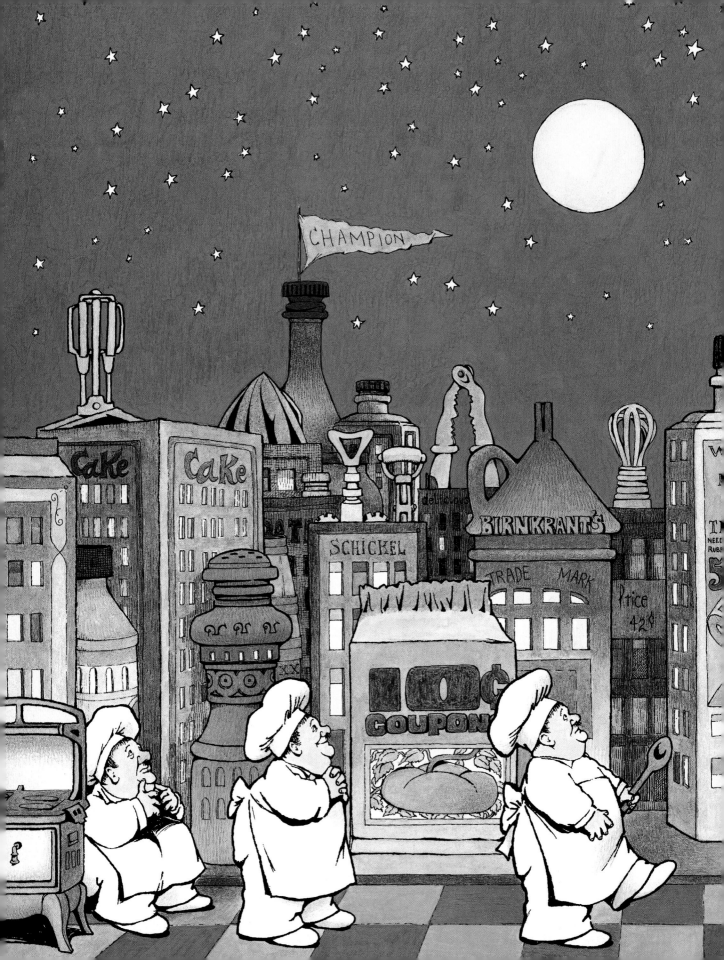

NUMBER TWO:
In the Night Kitchen

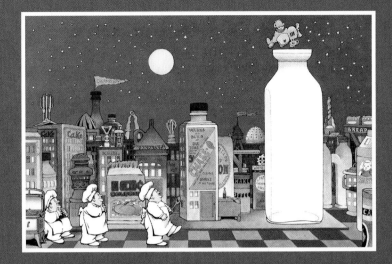

Here's a good example of what I mean by the apparent flatness and the theatrical two-dimensionality of Sendak's pages. Though the book features ceaseless movement, Mickey is pictured here at a point of perfect balance. Up high, he's settled down at last.

The three Oliver Hardy bakers perform some of the same function as the wild things from the previous page. Notice their attention, their movement and arrest, the geometrically increasing distances from one figure to another. The bakers' placement and gestures set up a rhythm of approach for the eye to work up to the leap above the milk bottle.

Before we pass along this gallery—not the temple of Sendak's muses, this time, but what those muses have helped inspire—consider that the environment of a city at night, a city as built by a child out of kitchen implements, household ordinaries, is also a clever model of how a child—anyone—invents with what is at hand.

Steals what is worth stealing, conscripts it into new service. In E. Nesbit's 1910 novel, *The Magic City*, plucky children build and visit a metropolis

whose streets are tiled with dominos, whose buildings sport columns made of silver candlesticks swiped off the sideboard. Children make; and dream; and make anew when they dream; and make anew again when they awake.

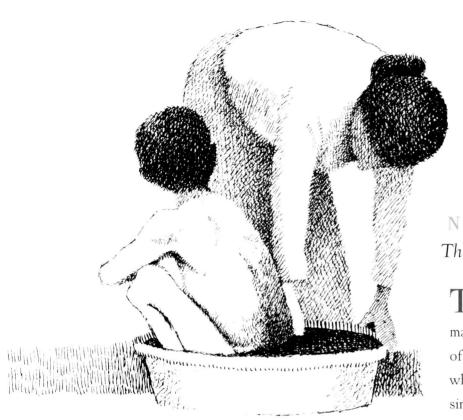

NUMBER THREE:
The House of Sixty Fathers

Though the subject matter recalls similar images of Degas, Millet, Cassatt, what I admire here is the simplicity of the gesture. For my money, Sendak's work for the Meindert Dejong stories, novels now considered rather too sweet for the public good, consistently ranks among his highest achievements. Specifically I refer to Sendak's economy of line, perhaps because he's so confident of the image he's decided to draw. One senses in this piece a giddy but mature delight at the effects the artist can achieve by stricter control of his medium.

Another image from the same period, though in a different medium, of course, that of ink wash. In other drawings from *The Wheel on the School* Sendak seems to have scrutinized the vigorous gnarls and whorls of van Gogh ink drawings, especially those of fields under cultivation. Here, one can be delighted, again, by the spare line, by the clarity of expressiveness in just a few scratchy marks, and by the careful control of the hue and value of the washes that serve to delineate characters hunched in their conundrum.

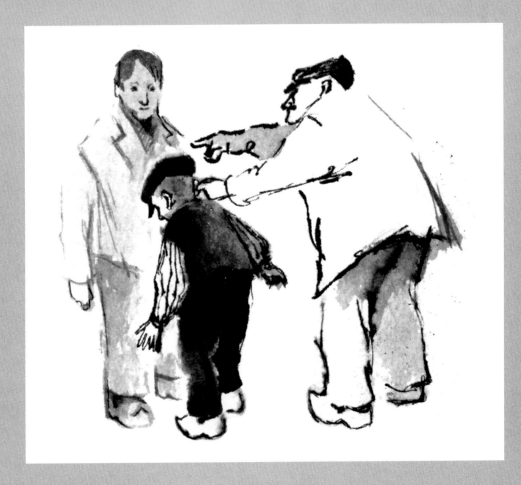

NUMBER FIVE:
The Golden Key

My choice for the fifth masterwork to preserve is from *The Golden Key*. Because of the paler color of ink, and because of the subject—the struggle through fog—this rendering doesn't clot into dark clutching recesses as Arthur Hughes's might, or, for comparison, as Edward Gorey's would. Instead, the backgrounds reveal, yield up their tender subject. I admire the shape of the page, the elimination of details that might distract attention more suitably paid to the brother and sister . . .

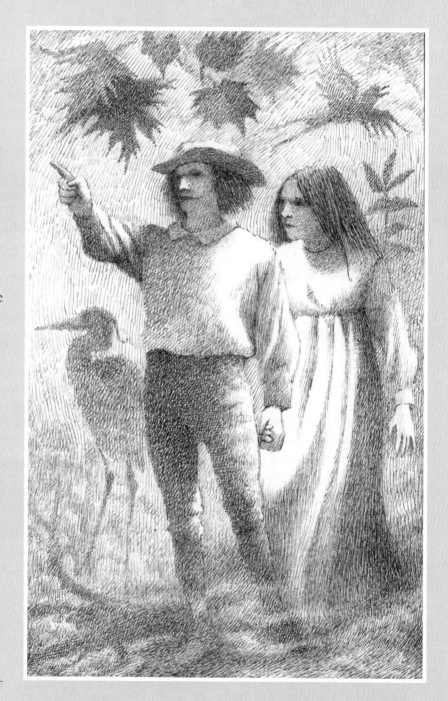

NUMBER SIX:
The Juniper Tree

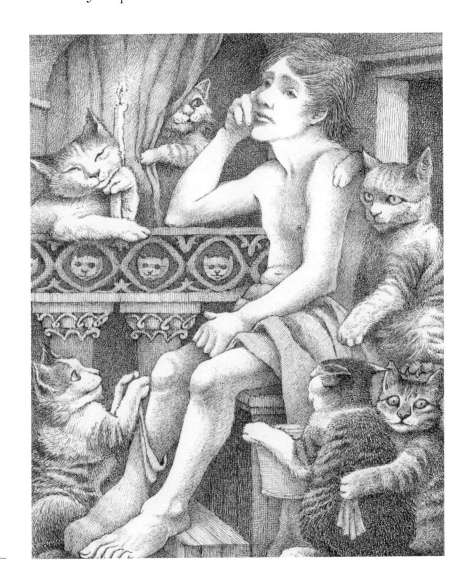

Number six is this boy with cats, from *The Juniper Tree.*

Jane Langton, the author of transcendentalist fantasies for children, said that any single drawing in *The Juniper Tree* seemed worthy of being the capstone of a whole life's work—and in *The Juniper Tree* Sendak bestows on us a whole book of them.

These cunning cats, in their cleverness and number, prefigure the kittens in *Jack and Guy.* I love the dreamy expression of the hapless guy who can't pull his own socks up.

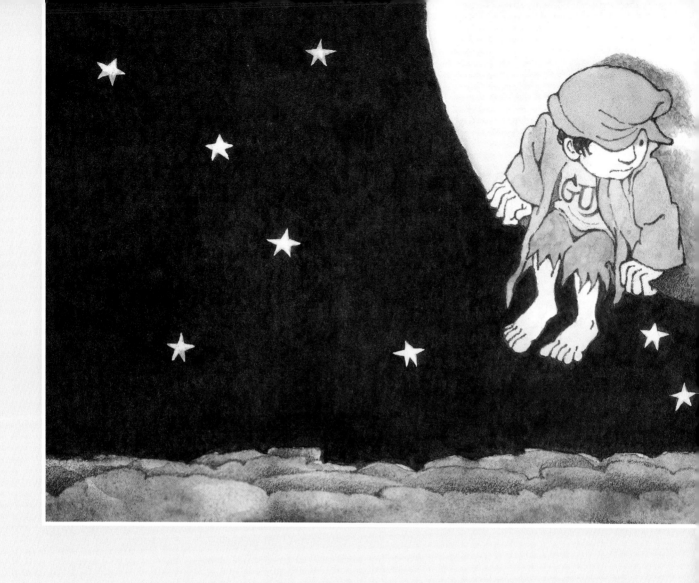

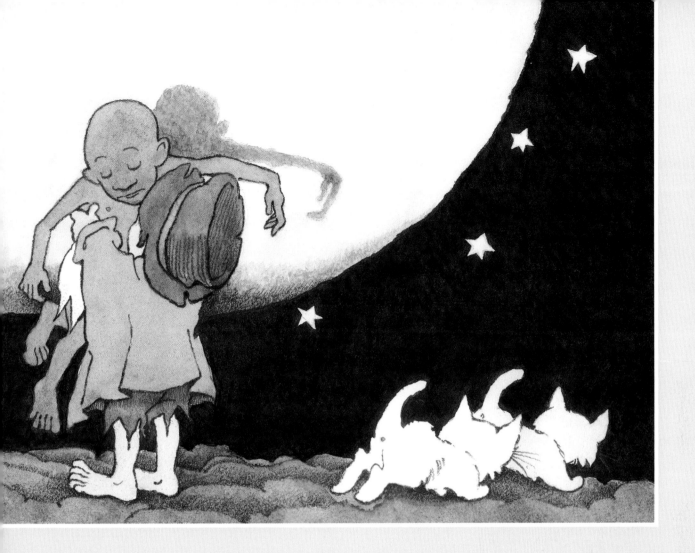

NUMBER SEVEN:
We Are All in the Dumps with Jack and Guy

The moon has been the basket in the bulrushes for these beleaguered street urchins. She is a deity of rage, pity, and vengeance, Old Testament in her sense of justice.

Wallace Stevens, writing by her light, says:

*It is equal to living
 in a tragic land
 To live in a tragic time.*

Sendak reminds us, iconographically, that every abuse is a sacrilege, and any mercy, however humble, is mighty as a miracle.

NUMBER EIGHT:
Fly by Night

More flying backward out the window into outside over there. This page, and perhaps some pages of *Dear Mili,* show Sendak moving about as far away as he can from the simplicity of the impish children in the early Ruth Krauss books. The double spread comes at the end of the pastoral poem of Randall Jarrell's dream sequence, a poem that circles in on itself, layer by layer, like a fable by Bidpai.

The drawing is of deepest vulnerability; that Samuel Palmer effect of which I wrote earlier comes to its final flourish here. It is a complicated drawing, and taken out of context it can seem over-busy. Yet the drawing serves the circular motion of the poem well. Despite the prominence of the sleeping boy in the foreground, the eye almost immediately moves around to the interwoven images of sheep and owl eyes and night sky and mothers. The boy is less a figure than a naked shape in a landscape more important than it is. Lambs are suckling, the Castle Yonder waits at the horizon, the owl is closer than the moon, a tombstone glistens in the light, and Mrs. Sendak at the foot of the tree holds her baby tight.

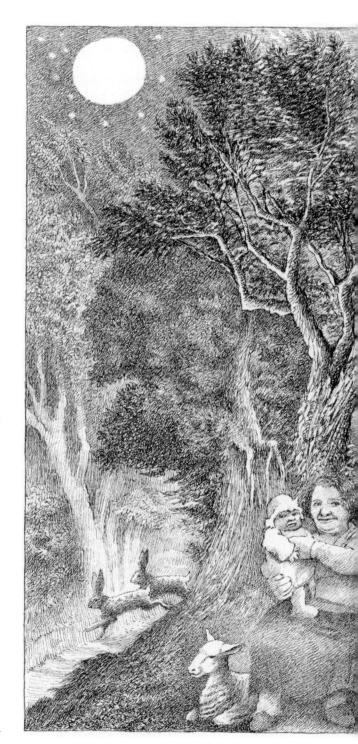

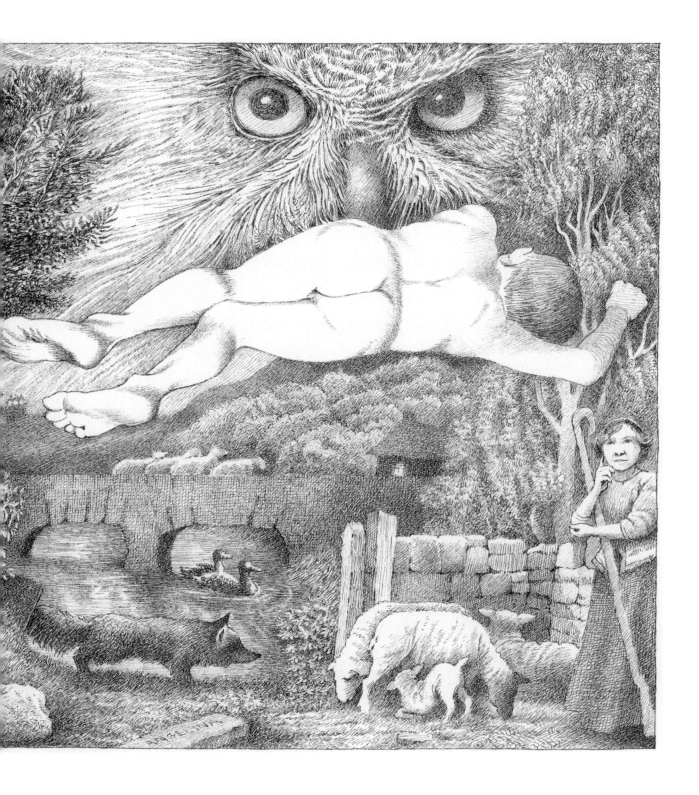

NUMBER NINE:
Higglety Pigglety Pop!
Or, There Must Be More to Life

The moon—as Mother Goose—comes into her own in this frame. She has hovered like a muskmelon on the edges of all Sendak's works, though in *Jack and Guy* and *Higglety Pigglety Pop!* she gets her own lines. From the baby who roars "No eat!" to the moon goddess who rewards Jennie with a job of eating in the theater for a living, Mother Goose deigns to settle to earth, dainty as a gentlewoman. The ripest nonsense in the world makes sense to her, and she makes sense of the ripest nonsense of our times.

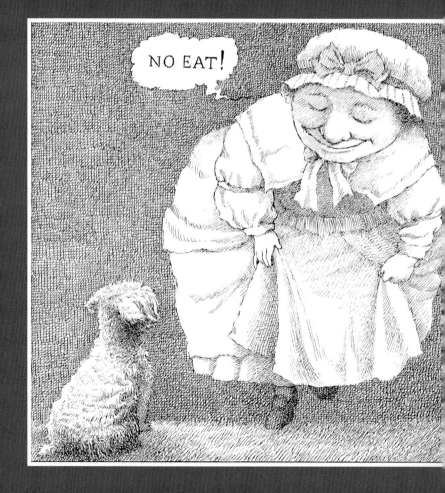

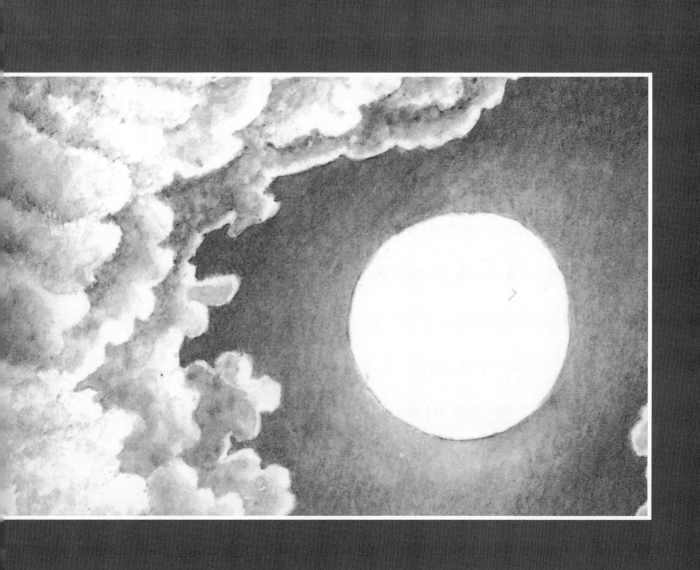

rendered pages, his most succinct and perhaps most graphically articulate expression of what pulls us from our dreamy slumbers, our invented havens, our various limbos and incarcerations.

———————————————

and it was still hot.

In August 2004, at a Children's Literature New England institute, I interviewed Maurice before an enraptured audience. We laughed a bit about witches and wild things, and how despite their apparent menace they were proving to be reliable offspring, continuing to forward royalty checks many years on. "What is Max doing these days, by the way?" I asked. Maurice replied that Max, an unmarried Jewish boy at the age of 76, not surprisingly was still living at home. With his mother. She had had to remake that wolf costume for him quite a few times. He didn't go out much except to see his therapist.

From behind a table I pulled a large piece of bristol board. "Draw him for us." Good-natured despite his reputation for orneriness—the pen completes the man—Maurice obliged. He presented us with Max at 76, making mischief of one kind or another still.

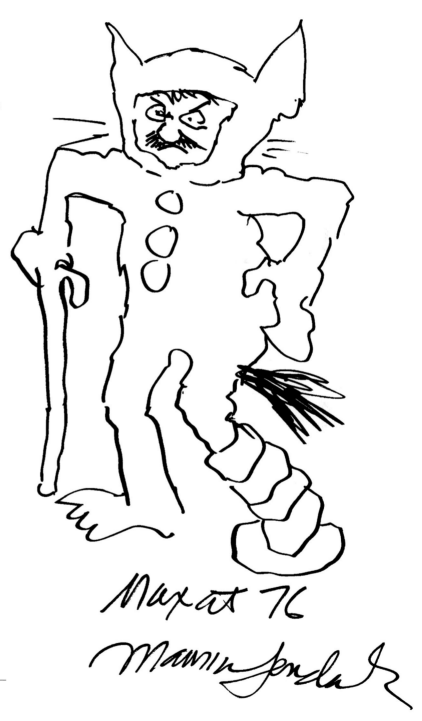

Max at 76

Maurice Sendak

[5]

MAURICE SENDAK IS QUOTED somewhere as saying something like "a mere change of sex can't disguise the essential Rosie-ness of my characters"—referring to Rosie from *The Sign on Rosie's Door*. Well, the man is entitled to his opinion. But however significant Rosie is as the head from which Max, Mickey, Ida, and the others have sprung, I think her importance is eclipsed by the forces of history. Wolf-suited Max has come to emblematize and codify the sharpest, keenest, most durable expression of Sendak's life themes. The story of Max and the wild things is as striking—as deeply felt, as elegantly executed, as emotionally pure, as significant, as *right*—as the story of Peter Rabbit in Mr. McGregor's garden, of Dorothy and her band of irregulars in Oz, of Alice descending into her own limbo.

With the text of *Where the Wild Things Are* as a guide, backward and forward across the half century of Sendak's output, we can hardly help but see its magnetic pull. Nearly every page of Sendak's work sounds a harmonic echo on the master theme and melody of *Wild Things*. Put another way, the master thief has stolen most often from himself.

And so, to finish, a final wild rumpus through random Sendak, celebrating the shape and meaning of what we can be confident in calling Sendak's immortal story.

But before I share it with you, let me confess that I prepared to deliver this closing section to the audience in Cambridge, Massachusetts, on that rainy morning in April 2003, without knowing that Maurice would have defied his stated expectations of tardiness, would have roused himself early from the hotel, and would have arrived just in time to settle in a chair hurried forward for him, right in the middle of the aisle in the very front of the room. Owl-eyed thanks to his thick glasses, both hands clasped atop the head of Beatrix Potter's stout walking stick, he might have been readying to present me with a beating for my nerve. I confessed to the audience, sotto voce over his head, that I had not expected, this morning or ever, to read aloud any version of *Where the Wild Things Are* to its author.

Let me read it to you.

Where the Wild Things Are
Story and Pictures by Maurice Sendak

The night Max wore his wolf suit
and made mischief of one kind

and another

his mother called him
"WILD THING!"
and Max said
"I'LL EAT YOU UP!"
so he was sent to bed
without eating anything.

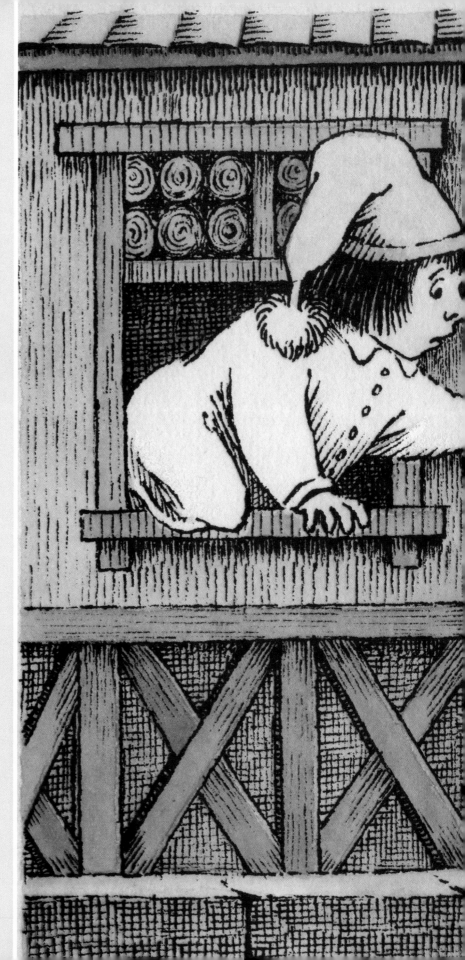

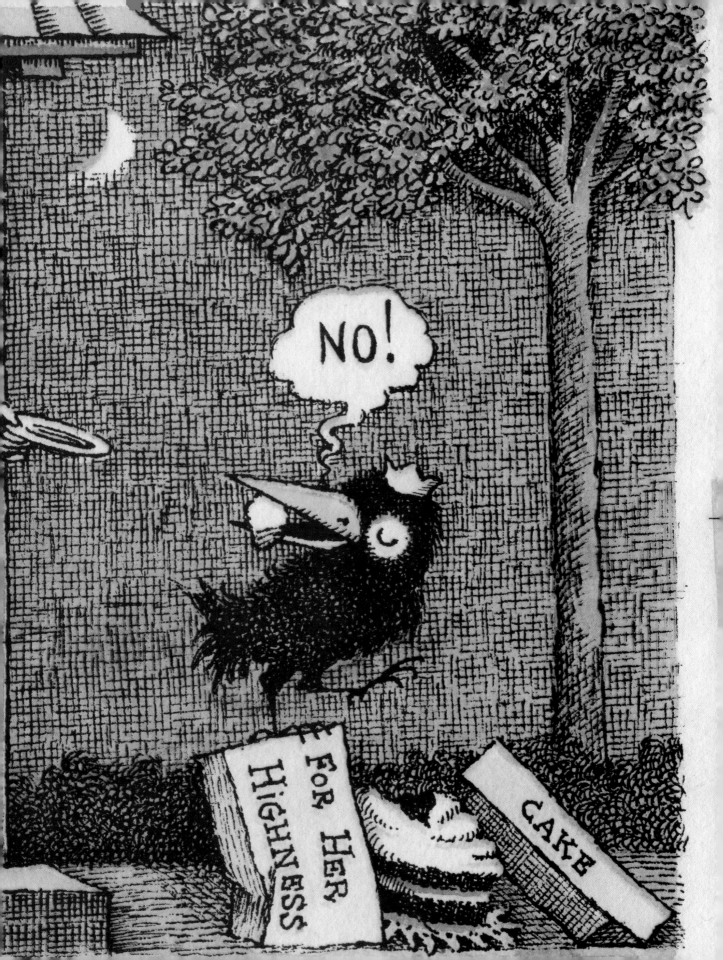

That very night in Max's room a forest grew

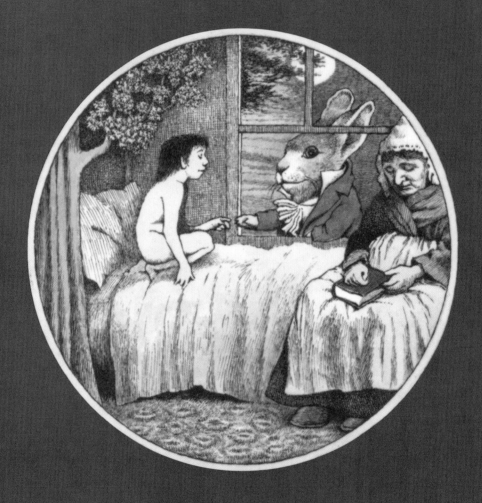

and grew—

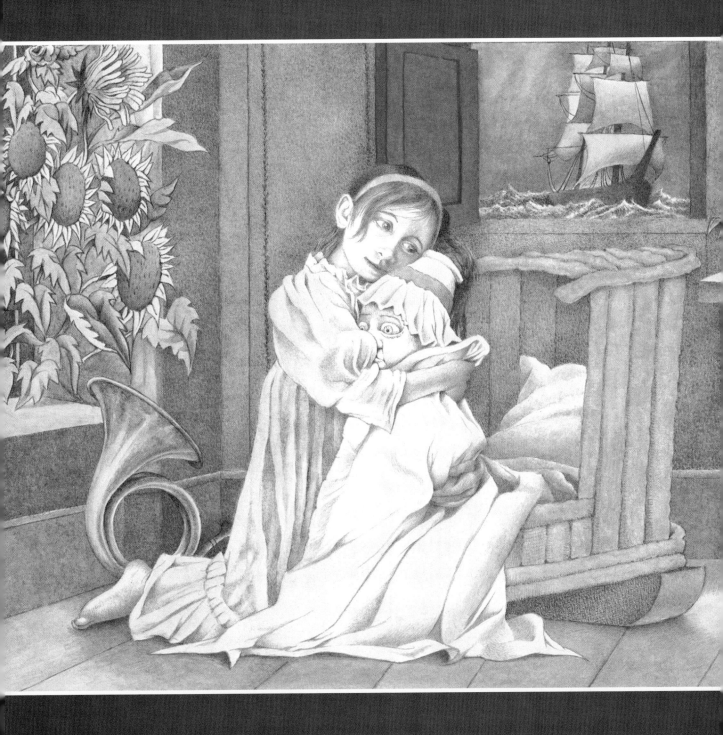

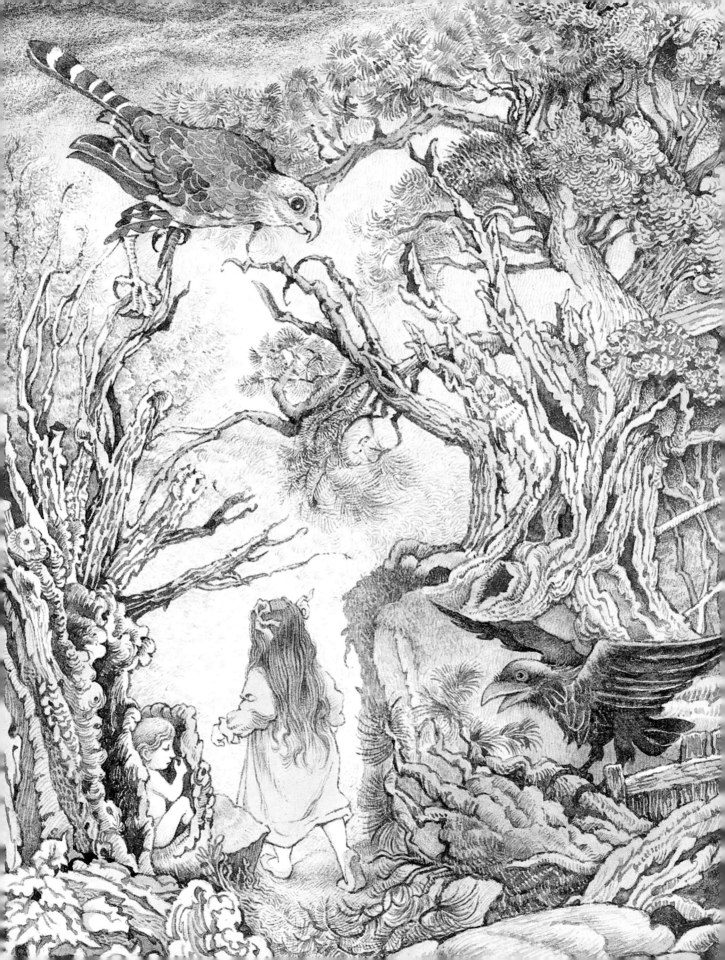

and grew until his ceiling hung with vines
and the walls became the world all around

and an ocean tumbled by with a private boat for Max
and he sailed off through night and day

and in and out of weeks
and almost over a year
to where the wild things are.

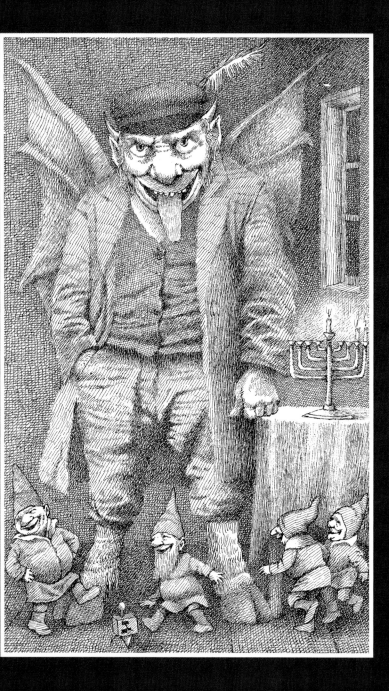

And when he came to the place where the wild things are they roared their terrible roars and gnashed their terrible teeth and rolled their terrible eyes and showed their terrible claws

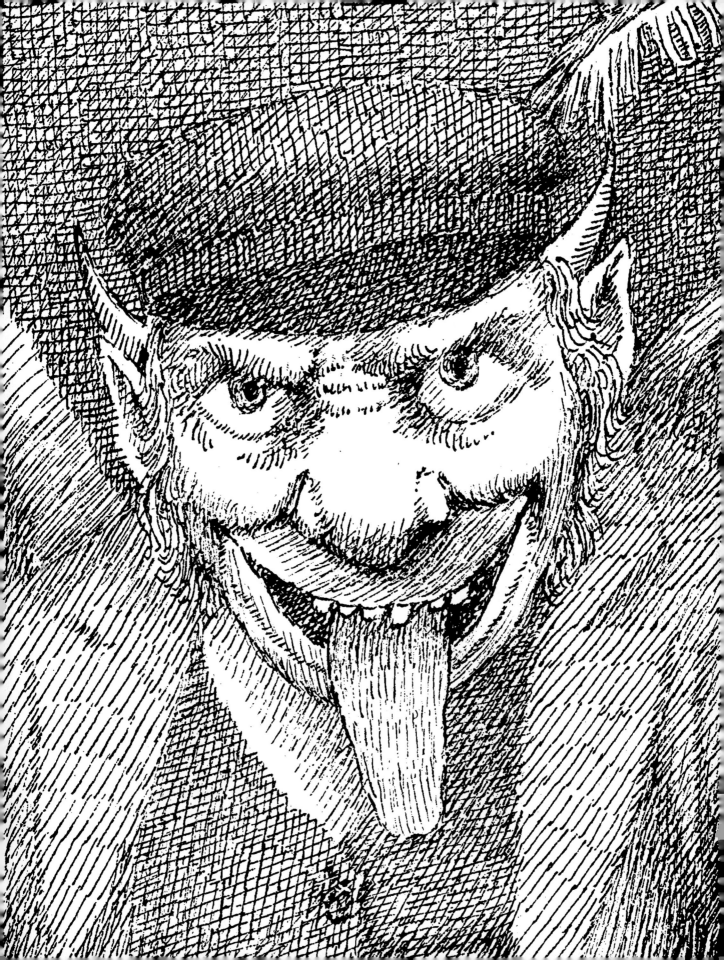

till Max said "BE STILL!"
and tamed them with
the magic trick of staring
into all their yellow eyes
without blinking once

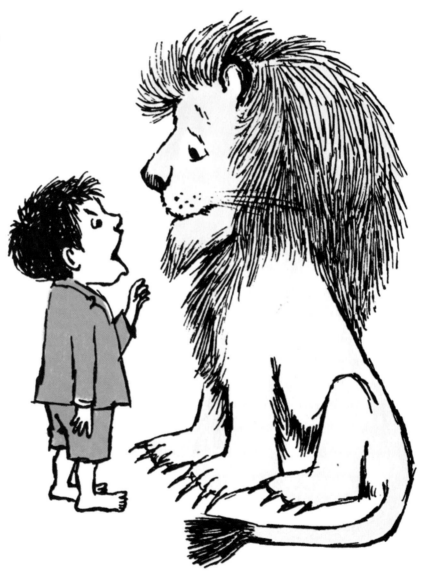

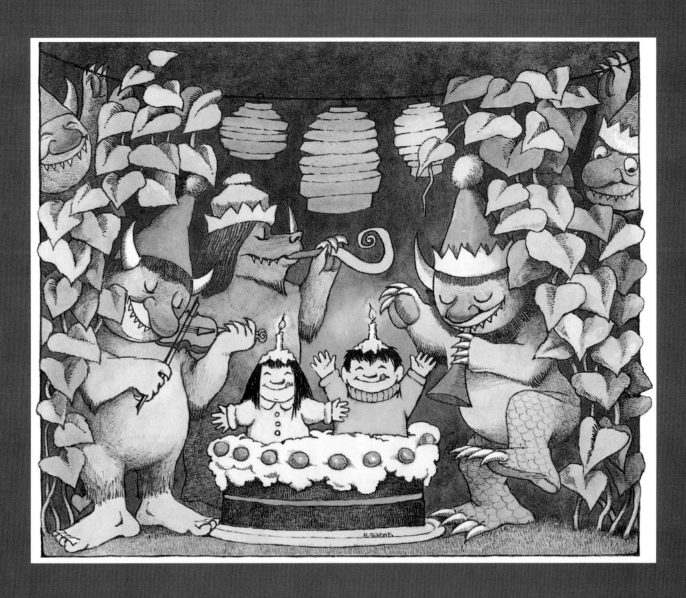

and they were frightened and called him the most
wild thing of all and made him king of all wild things.
　　"And now," cried Max, "let the wild rumpus
start!"

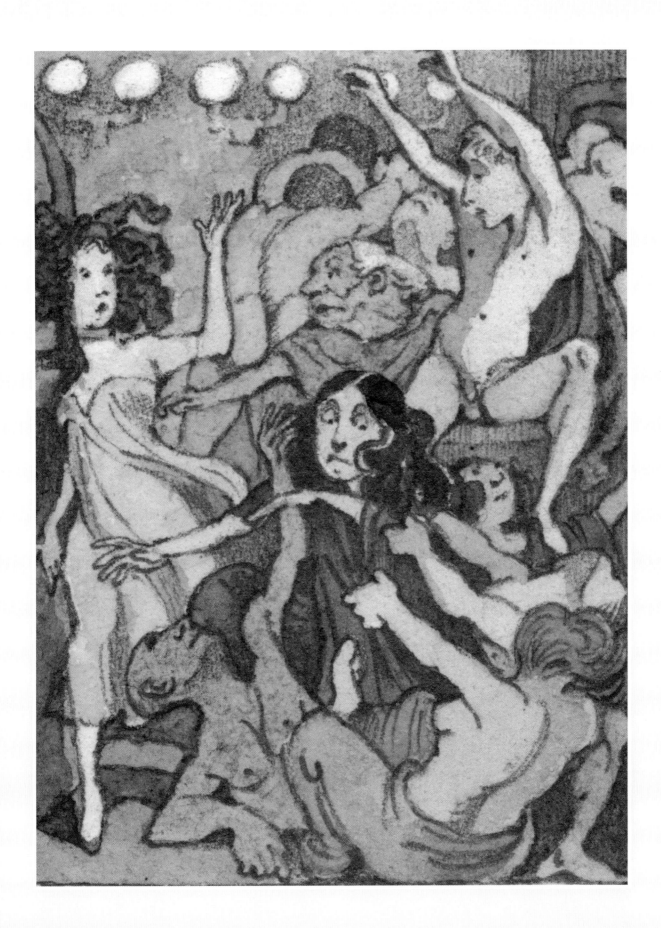

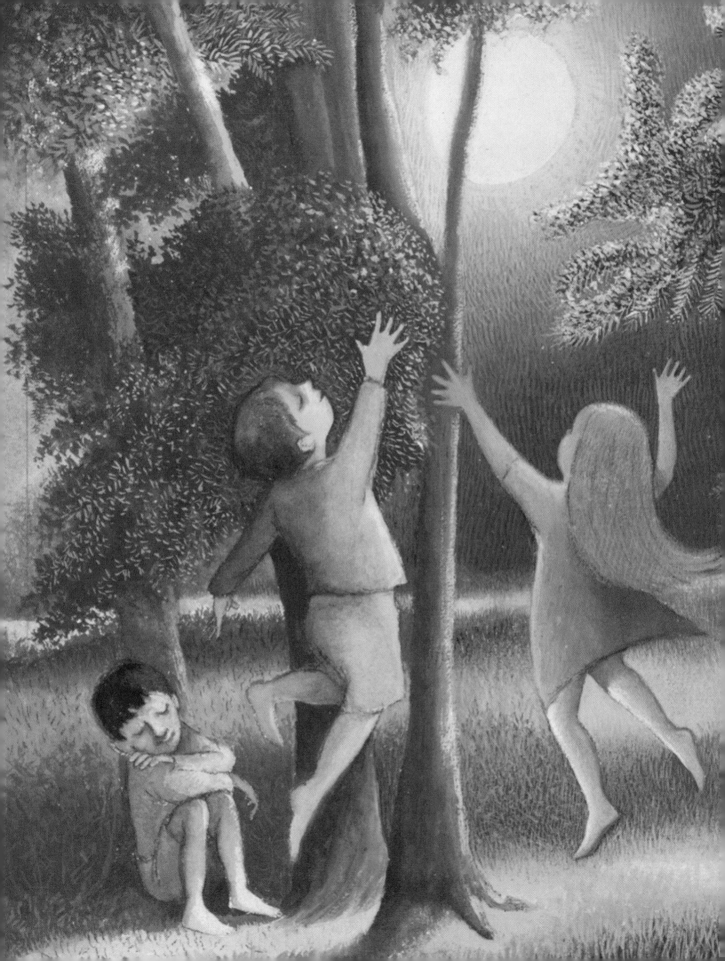

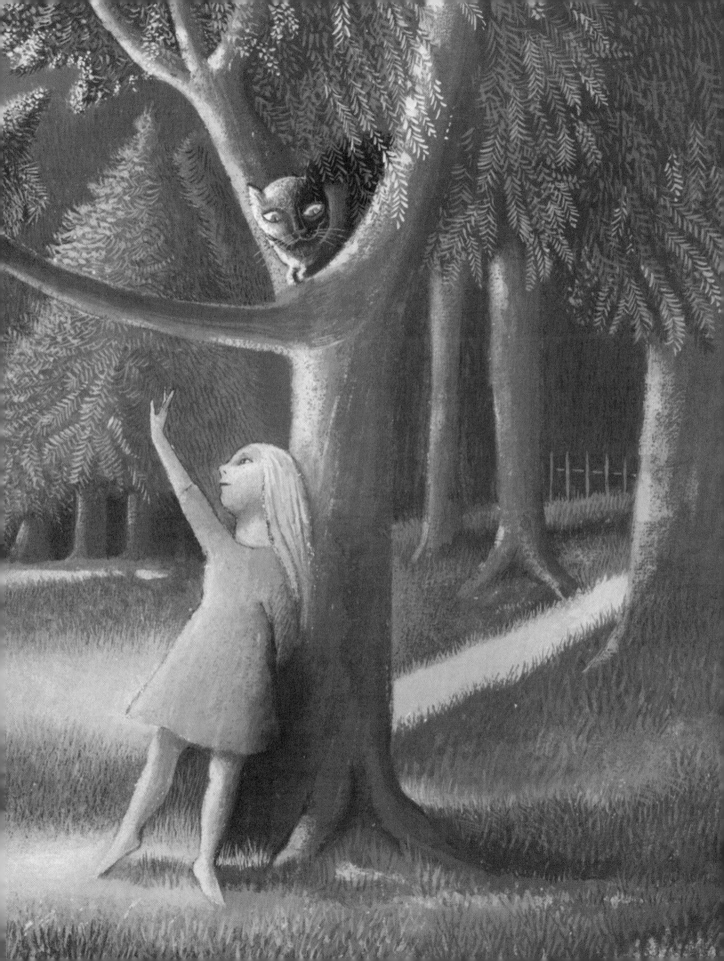

ow stop!" Max said and
sent the wild things off to bed
without their supper. And
Max the king of all wild things
was lonely and wanted to be
where someone loved him
best of all.

Then all around from
far away across the world
he smelled good things to eat
so he gave up being king of
where the wild things are.

But the wild things cried,
"Oh please don't go—
we'll eat you up—we love
you so!"
 And Max said, "No!"

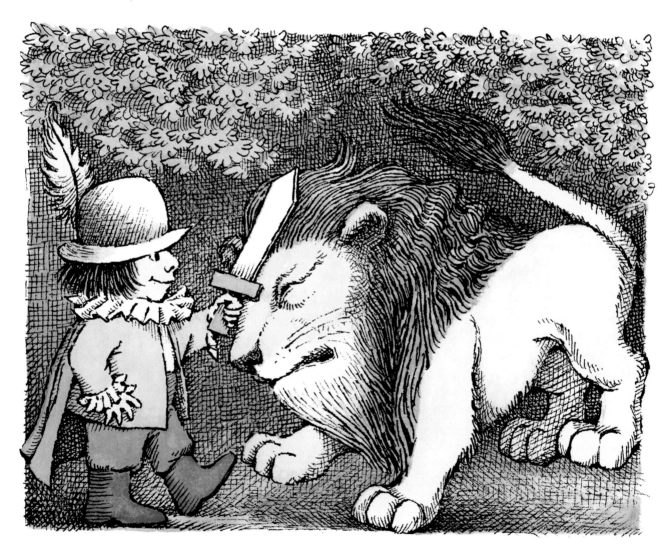

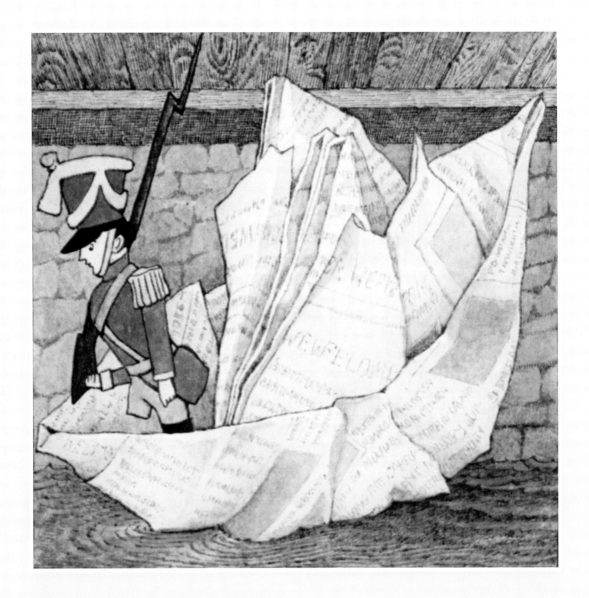

The wild things roared their terrible
roars and gnashed their terrible teeth
and rolled their terrible eyes and
showed their terrible claws but Max
stepped into his private boat and
waved good-bye

and sailed back over a year
and in and out of weeks
and through a day

and into the night of his very
own room where he found his
supper waiting for him.

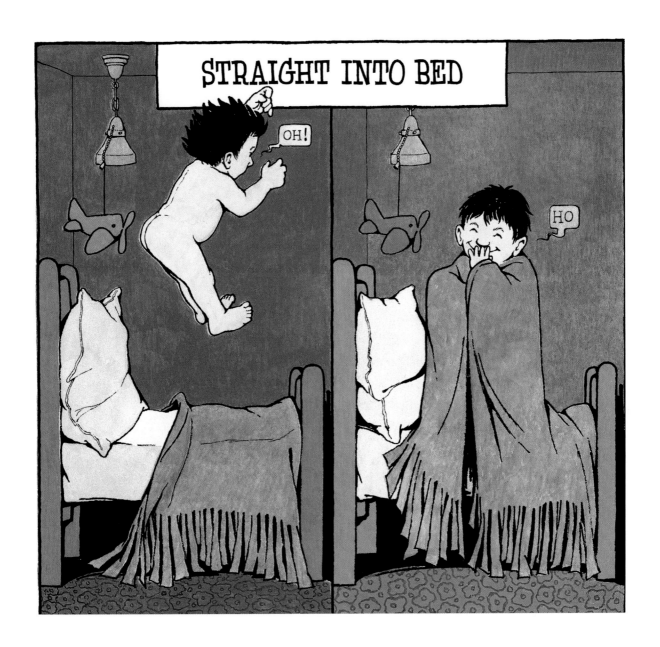

(And do you know who Max's mother really is? Who she has to be? The unseen mother at the heart of the story? What do you think, dear? One guess.

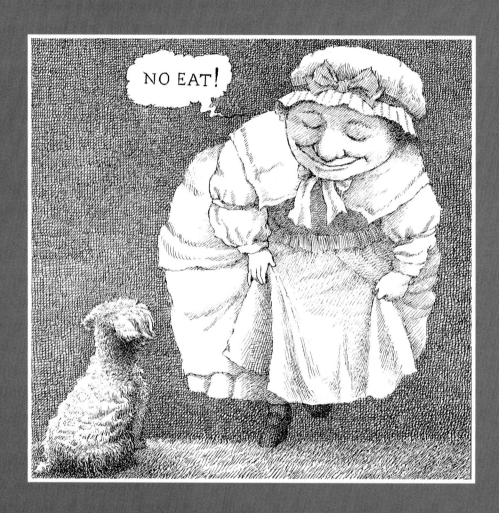

Of course. It's Mother Goose having survived her griefs, still giving, still beaming. The bright light of the moon at the very top of Sendak's household pantheon. It has to be. Because, really, it's just plain old magic. After all these years, for Max, for all of us, the supper is still hot . . .)

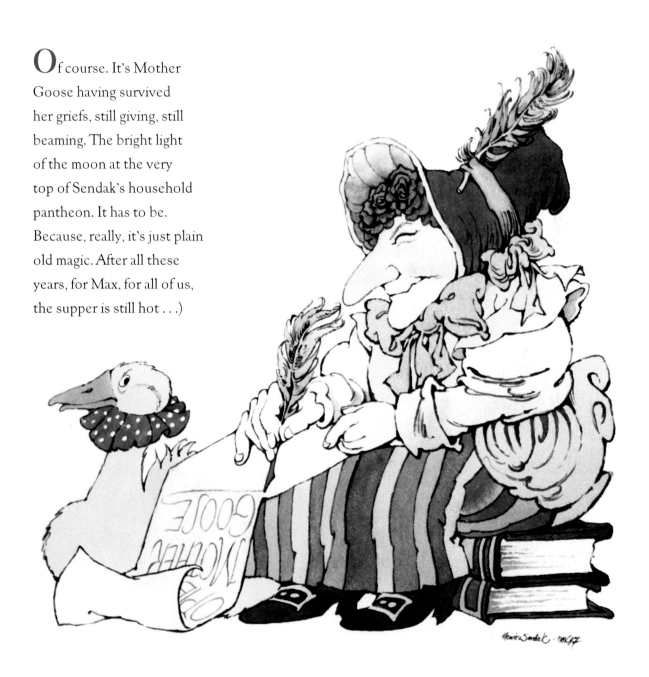

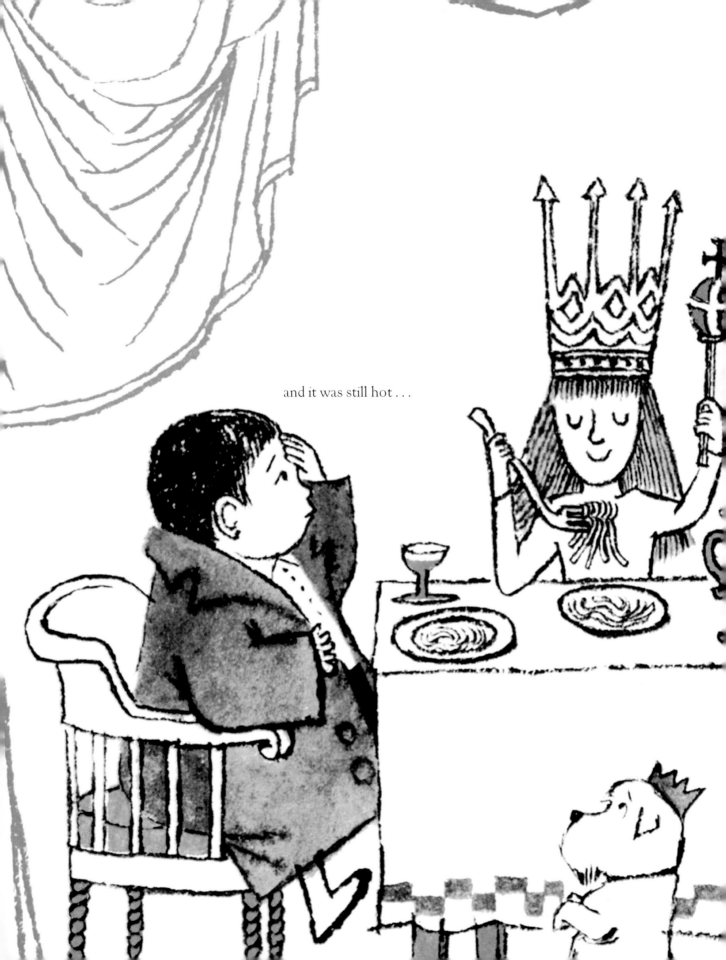

and it was still hot . . .

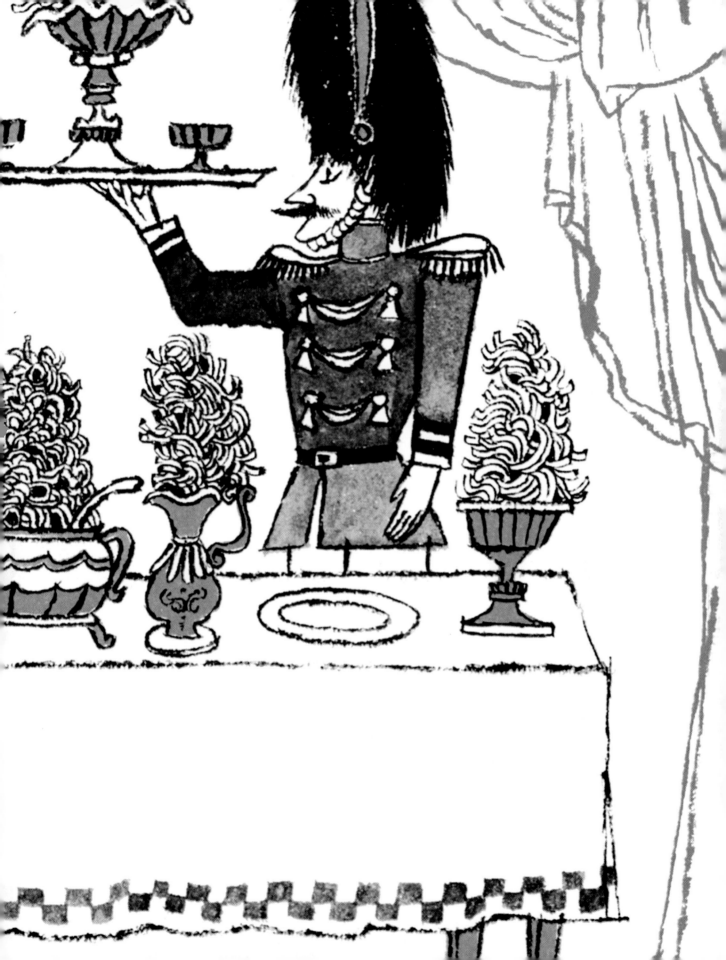

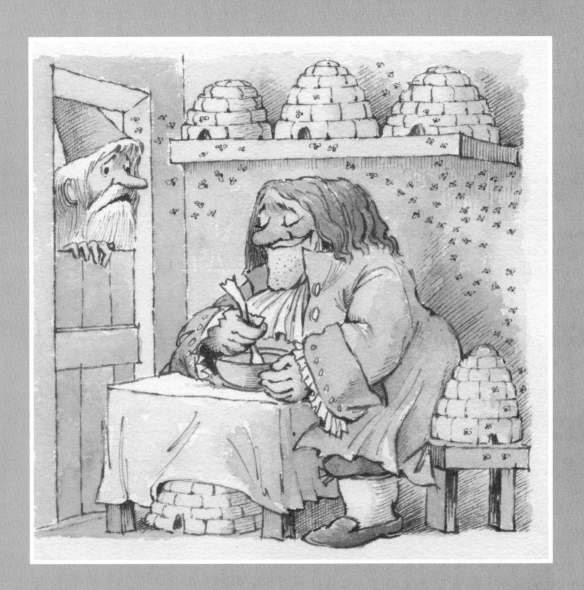

and it was still hot . . .

and it was still hot.

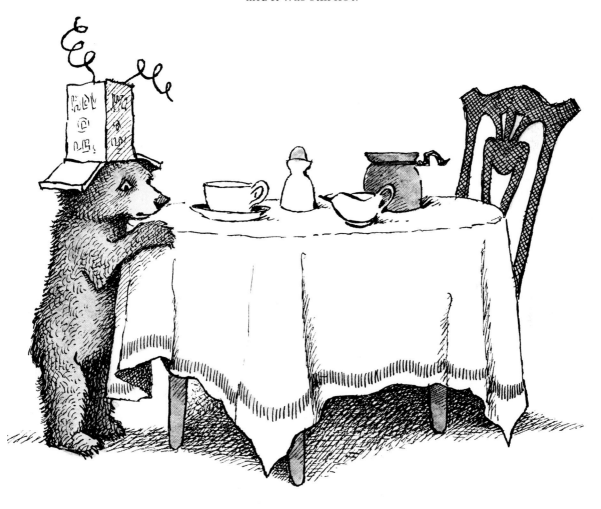

And it was still hot.

And it was still hot.

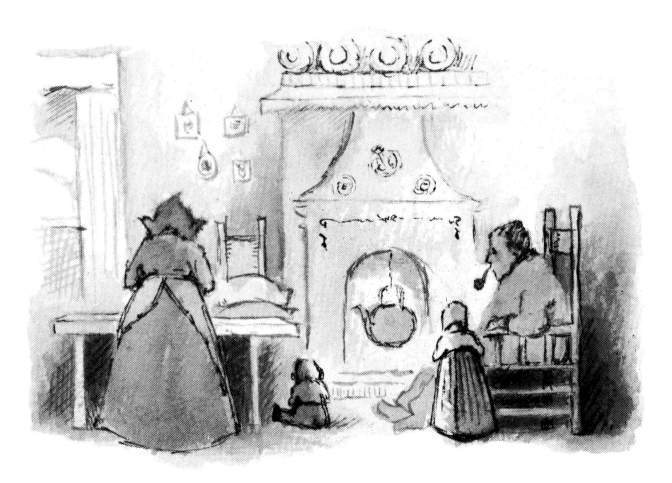

And it was still hot.

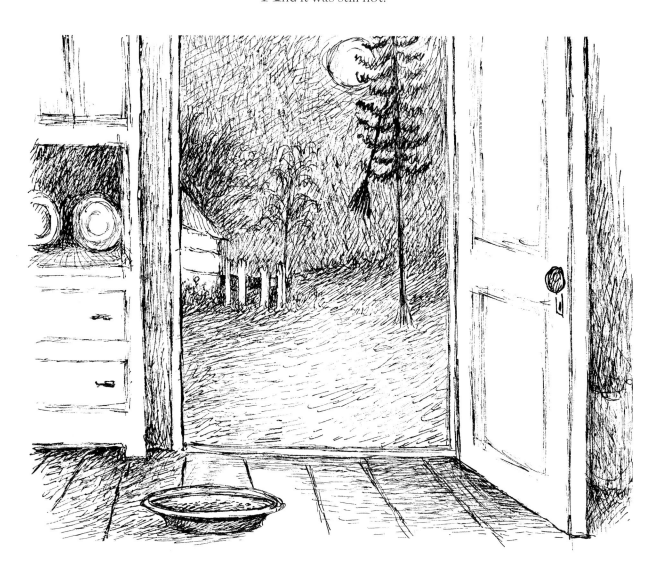

And it was still hot.

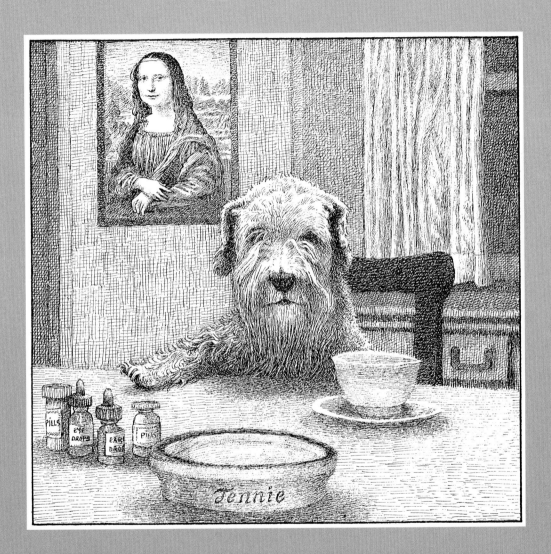

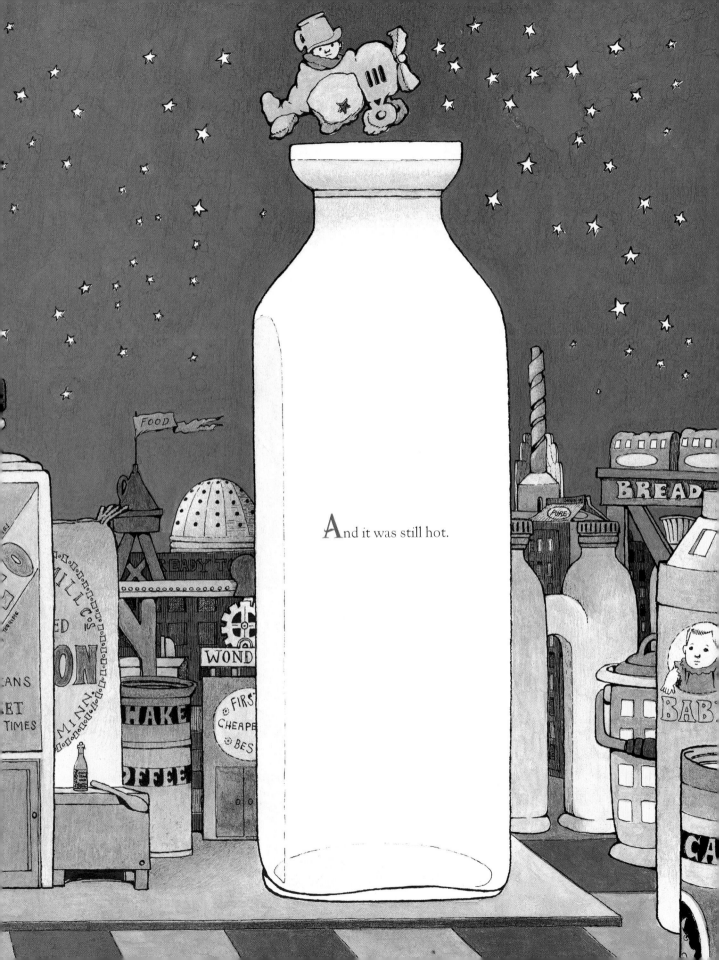

And it was still hot.

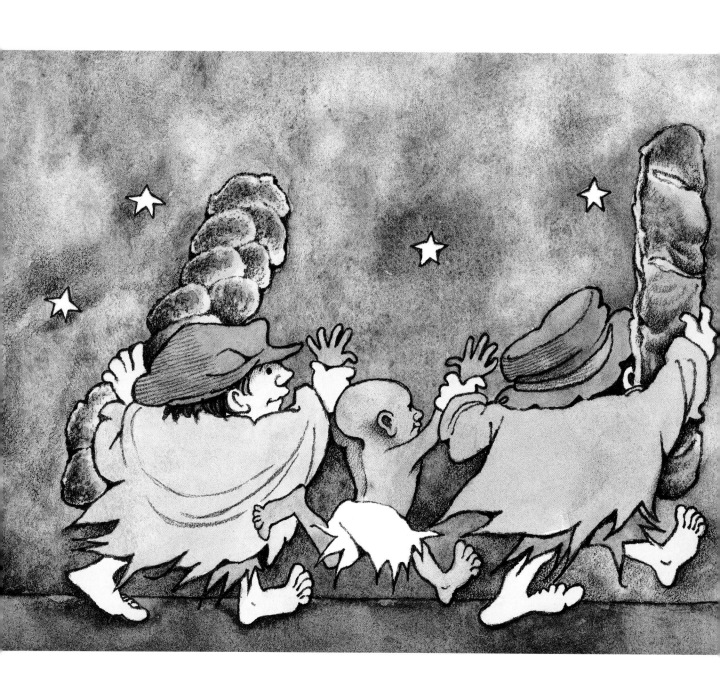

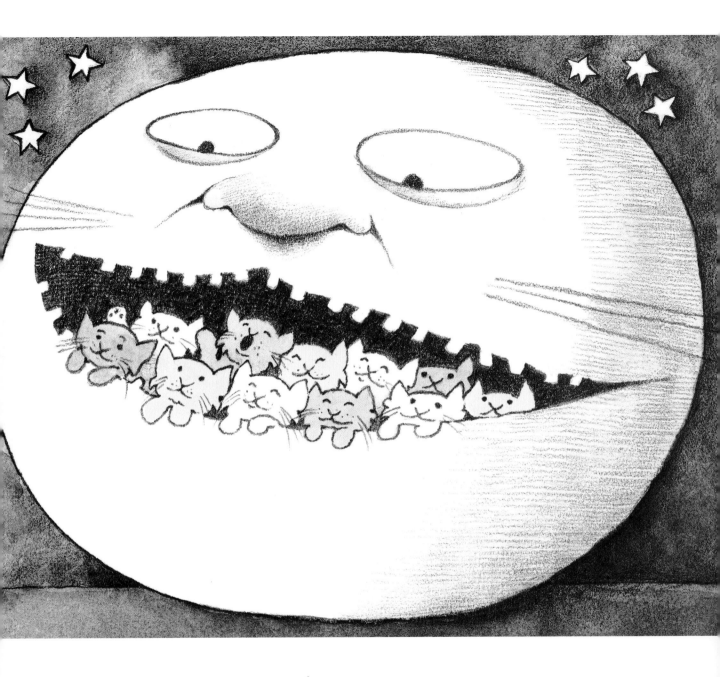

And it was still hot.

And it was still hot.

And it was still hot.

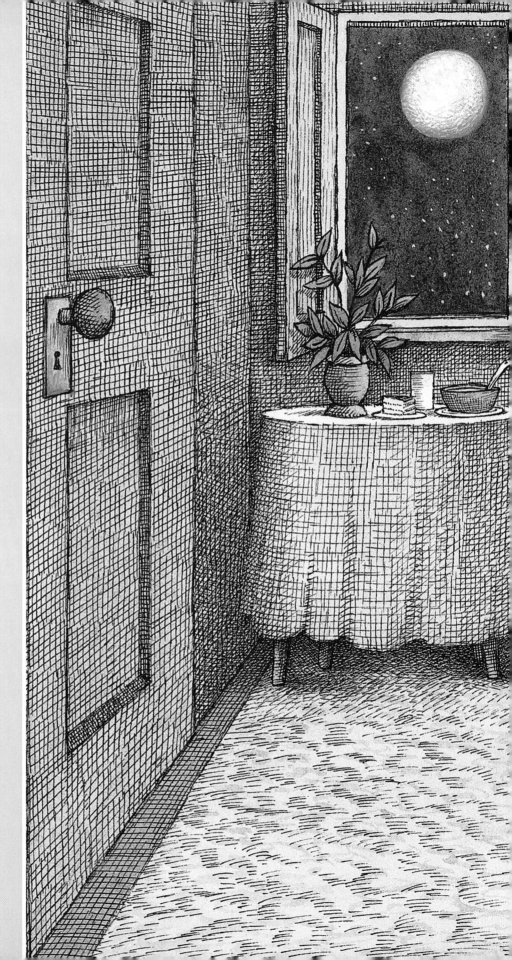

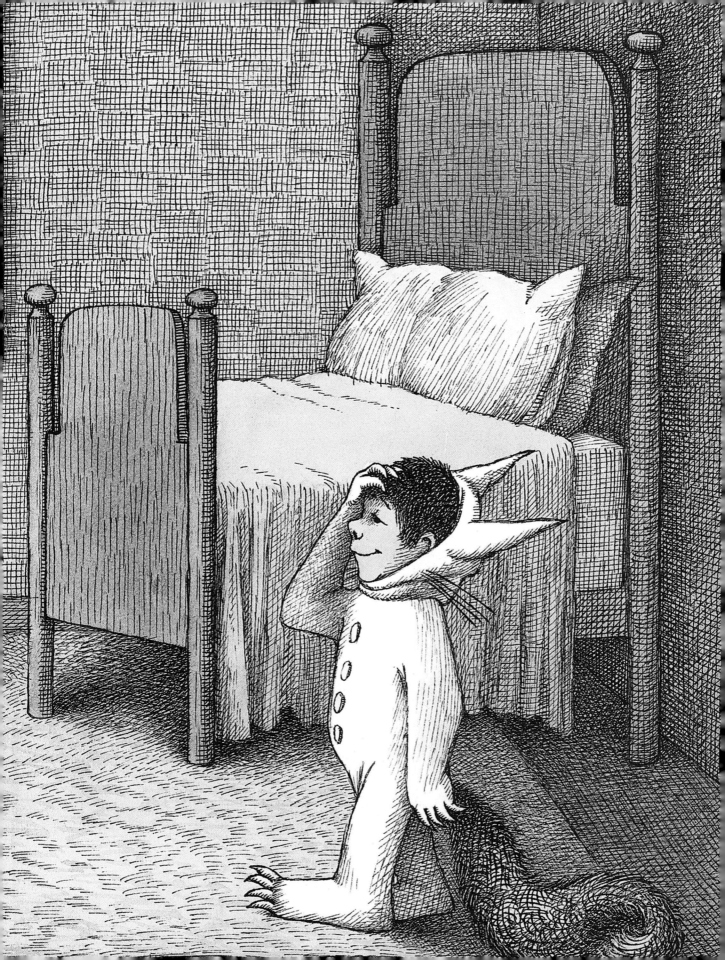

ACKNOWLEDGMENTS

Thanks are due:

for courteous help and friendship at Maurice Sendak's home and studio, to Maurice Sendak; Lynn Caponera; Harrison Judd, archivist; Jennifer Lavonier, assistant to MS;

for dedication at William Morrow, an imprint of HarperCollins, to Cassie Jones, Susan Kosko, Jessica Deputato, Betty Lew, Liate Stehlik, Lisa Gallagher, Johnathan Wilber;

for help in acquiring elusive images and permissions, to William Reiss of John Hawkins and Associates and to Frederick Courtright, The Permissions Company;

for the permission to reproduce Sendak's Buster Keaton drawing and the cover to *A Perfect Friend*, to Justin G. Schiller, Dennis M. V. David, and Battledore Limited;

for the scanning of archival materials at the Boston Public Library, to Thomas Blake, digital imaging production manager; Mary Beth Dunhouse, coordinator of resources and processing; Stuart T. Walker, conservator; Betsy Hall, executive director of the Associates of the Boston Public Library; Vivian Spiro, chair of the board of directors of the Associates of the Boston Public Library;

for permission to reprint the logo of the *Horn Book Magazine* (in which a version of chapter four of this work appeared), to Roger Sutton;

for permission to quote from my review of *Brundibar*, to the *New York Times Book Review*;

for support of and interest in *Making Mischief* as expressed by the American Library Association's cohosts of the 2003 May Hill Arbuthnot Lecture by Maurice Sendak, to Daryl Mark and Susan Flannery of the Cambridge Public Library; to Barbara Harrison, Barbara Scotto, Martha Walke, and Virginia Golodetz of Children's Literature New England; to Paul Parravano and MIT; and to Joanna Rudge Long and the 2003 May Hill Arbuthnot Committee;

for help in finding an elusive Sendak image, to Stephen Coren of Coren Graphics;

for scanning of GM's private Sendak materials, to Jay Crowley of Jay's Publishers Services, Hanover, Massachusetts;

for images loaned from and scanned by the Rosenbach Museum and Library in Philadelphia, to Derick Dreher, director; Judith M. Guston, curator and director of collections; Patrick Rodgers, traveling exhibitions coordinator; Karen Schoenewaldt, registrar;

for permission to reprint the image of Bugs Bunny drawn by Chuck Jones for MS, to the Chuck Jones family;

for wizardry in the GM office, to Emily Prabhaker, assistant; Liz Kaupelis, office manager; Lori Shelly, personal assistant;

for unstinting help in making of my life a peaceable kingdom, surpassing what I might ever have hoped for, to Andy Newman.

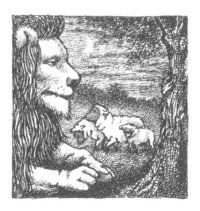

FINIS

CREDITS

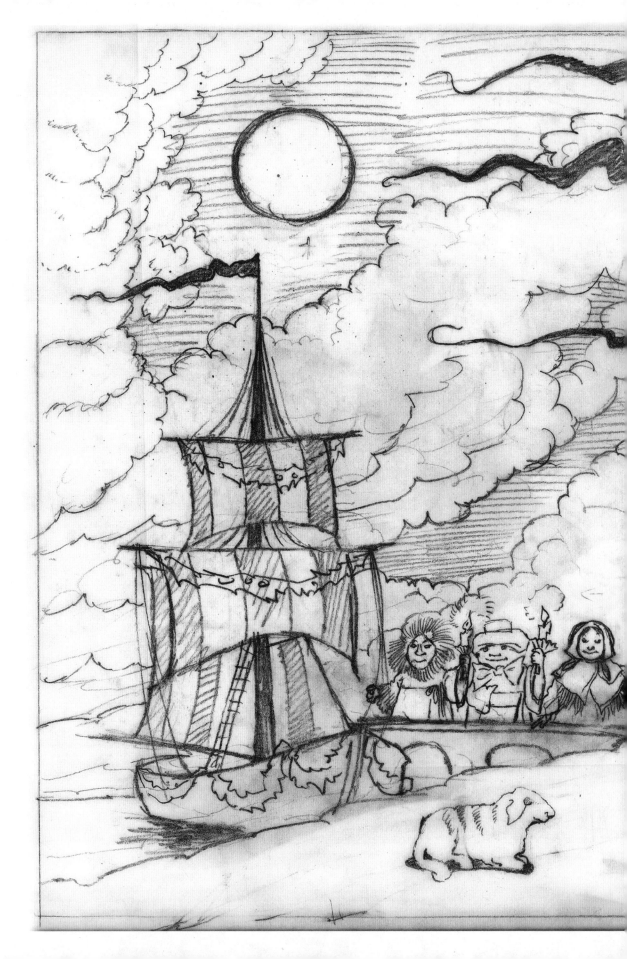